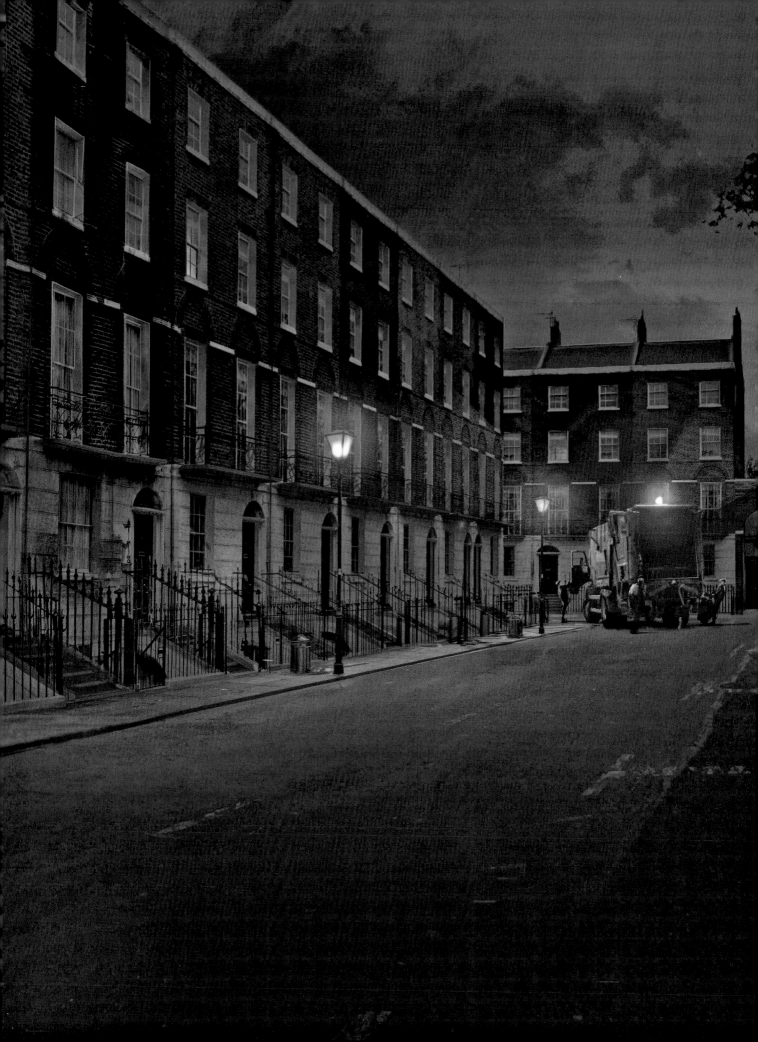

FILM VAULT

Volume 10

Wizarding Homes and Villages

By Jody Revenson

WIZARDING WORLD

INSIGHT EDITIONS

San Rafael · Los Angeles · London

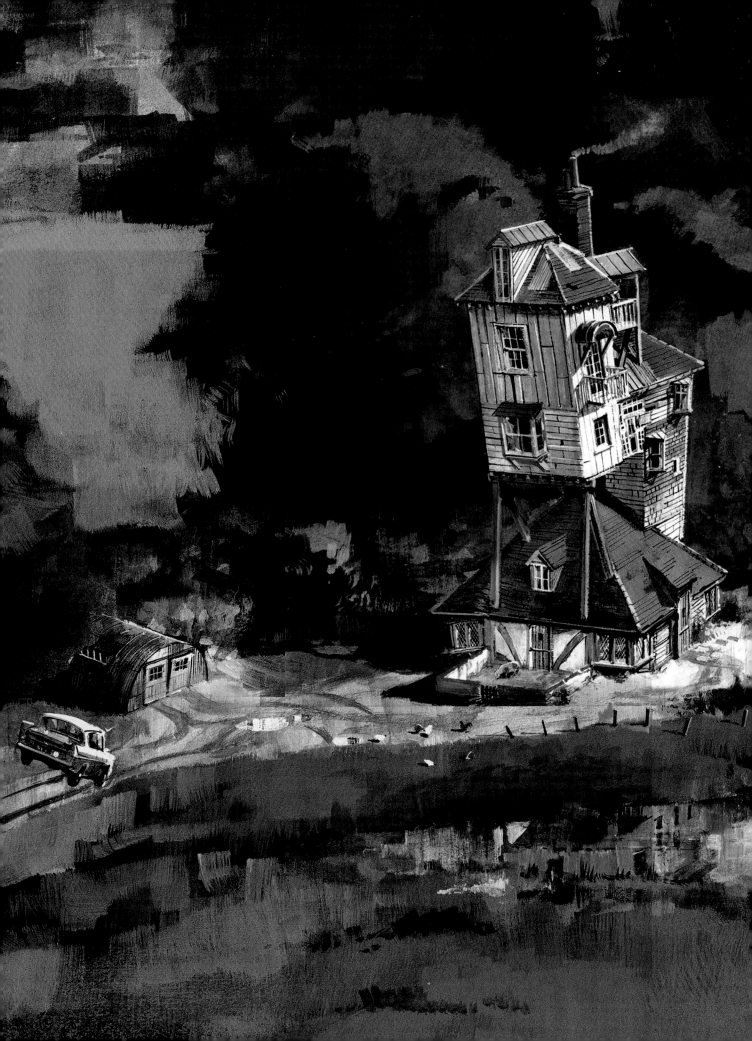

INTRODUCTION

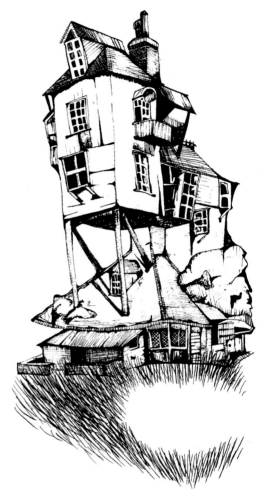

When Harry Potter is introduced to the wizarding world, he learns that wizards and witches have been living among Muggles for generations. There are pockets in the city of London and its environs where wizards reside and form communities, with shopping and lodging and transportation services. There are houses and estates spread across England, some set in full view of Muggle neighbors and others in quiet, isolated countrysides or next to wave-battered beaches. There are also villages that are mostly or entirely populated by wizards and witches.

Hogsmeade and Godric's Hollow are two such wizarding settlements. Tucked into the Scottish Highlands right next door to Hogwarts School of Witchcraft and Wizardry, Hogsmeade is the only all-wizarding village in Britain. "Hogsmeade is the country version of Diagon Alley," says production designer Stuart Craig, comparing it to the shopping and lodging district set in the middle of London. "It is just off the perimeter road around Hogwarts." Wanting to give Hogsmeade a theme distinctively different from the Victorian-style Diagon Alley, Craig set Hogsmeade above the tree line, high in the mountains. Though perpetually covered in snow, the village is warmed by its friendly inhabitants, in addition to two public taverns, the Hog's Head and the Three Broomsticks. Its many shops provide the nearby students with school and sports supplies, joke and trick items, and sweets. On its outskirts is the most haunted house in the country.

PAGE 2: *Concept art by Andrew Williamson for* Harry Potter and the Chamber of Secrets *shows the flying Ford Anglia arriving at The Burrow.* OPPOSITE: *Concept art by Andrew Williamson for* Harry Potter and the Order of the Phoenix *of Grimmauld Place, where the ancestral home of the Black family is hidden by a Fidelius Charm.* RIGHT: *Sketch of the Weasley family home, The Burrow.* BELOW: *Daniel Radcliffe, Emma Watson, and Rupert Grint pose on the Hogsmeade set in* Harry Potter and the Prisoner of Azkaban.

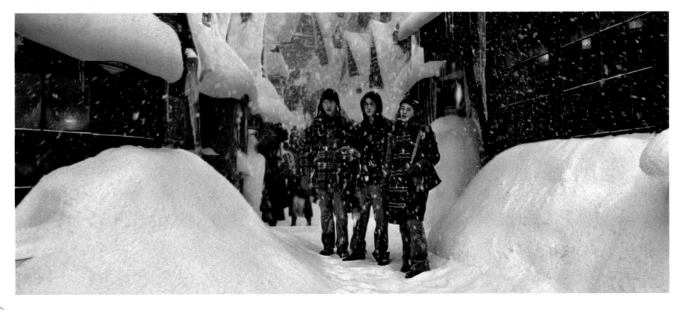

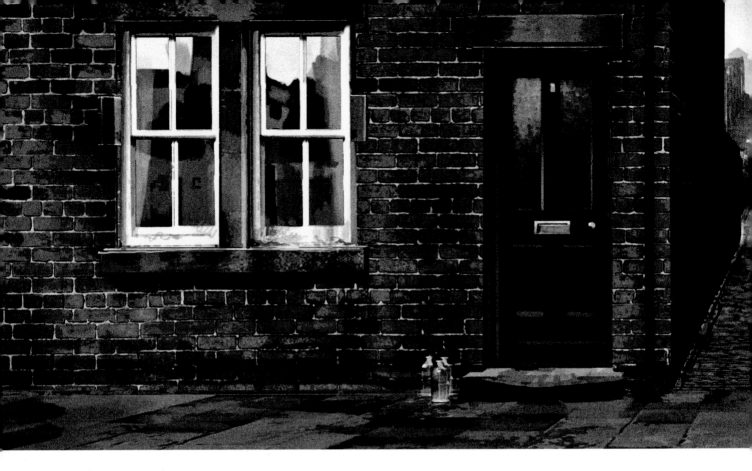

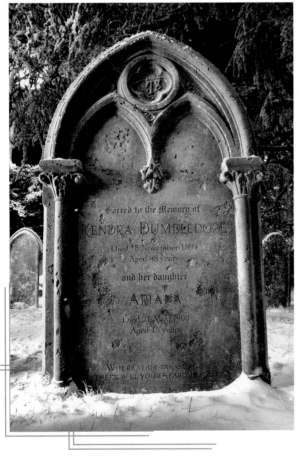

While Godric's Hollow is not a wholly wizarding village, it is the birthplace of Godric Gryffindor, one of the founders of Hogwarts, and home to some of the most famous wizarding families throughout history. Within its churchyard is the tomb of at least one of the three Peverell brothers, believed to have participated in the creation of the Deathly Hallows. Prominent residents have included the family of Hogwarts Headmaster Albus Dumbledore, noted historian Bathilda Bagshot, and James and Lily Potter, Harry's parents, who were killed by Voldemort in their small cottage. Stuart Craig and location manager Sue Quinn toured the hamlets in Suffolk and found Lavenham, "which is the most spectacular, the most beautiful of those rich Suffolk villages," says Craig. "We decided it had a style we hadn't exploited before at all, with a southern England home-counties look to it. It seemed very appropriate, and also quite a dramatic change, architecturally."

Not all wizards or witches live within dedicated magical communities, establishing their homes in more remote areas. Two of the most prominent wizarding families, the Weasleys and the Malfoys, have houses surrounded by extensive lands. Malfoy Manor was built within a circle of southwest English counties. The Burrow is also in the southwest, in Ottery St. Catchpole, and near several other wizarding families, including that of Xenophilius Lovegood, editor of the controversial newspaper *The Quibbler*. Craig set the Lovegood house in a landscape similar to the isolated marshy ground surrounding The Burrow. "The magical houses do better in desolate places not easily visible to the Muggle world," he explains. "This gives them an inaccessibility that is a prerequisite, I think, for a wizarding home

LEFT: *The gravestone for Kendra and Ariana Dumbledore on the Godric's Hollow set for* Harry Potter and the Deathly Hallows — Part 1. TOP: *Concept art by Andrew Williamson for* Harry Potter and the Half-Blood Prince *depicts Bellatrix Lestrange and Narcissa Malfoy on their way to Severus Snape's home in Spinner's End.* RIGHT: *Harry Potter (Daniel Radcliffe), Hermione Granger (Emma Watson), and Ron Weasley (Rupert Grint) in Ron's bedroom in The Burrow in* Half-Blood Prince.

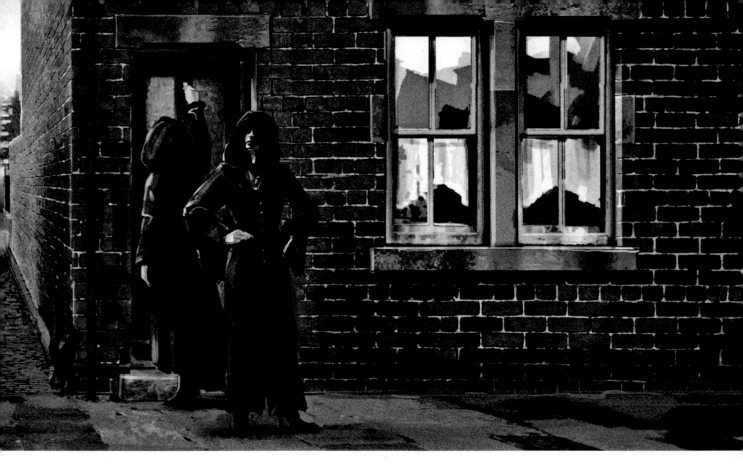

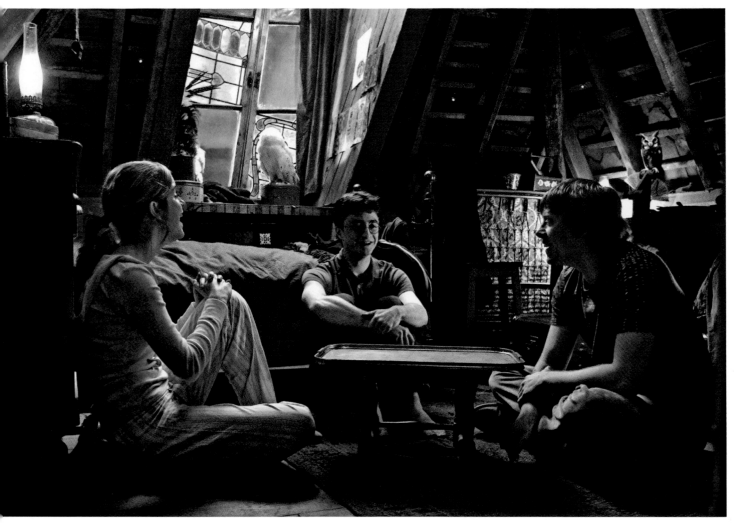

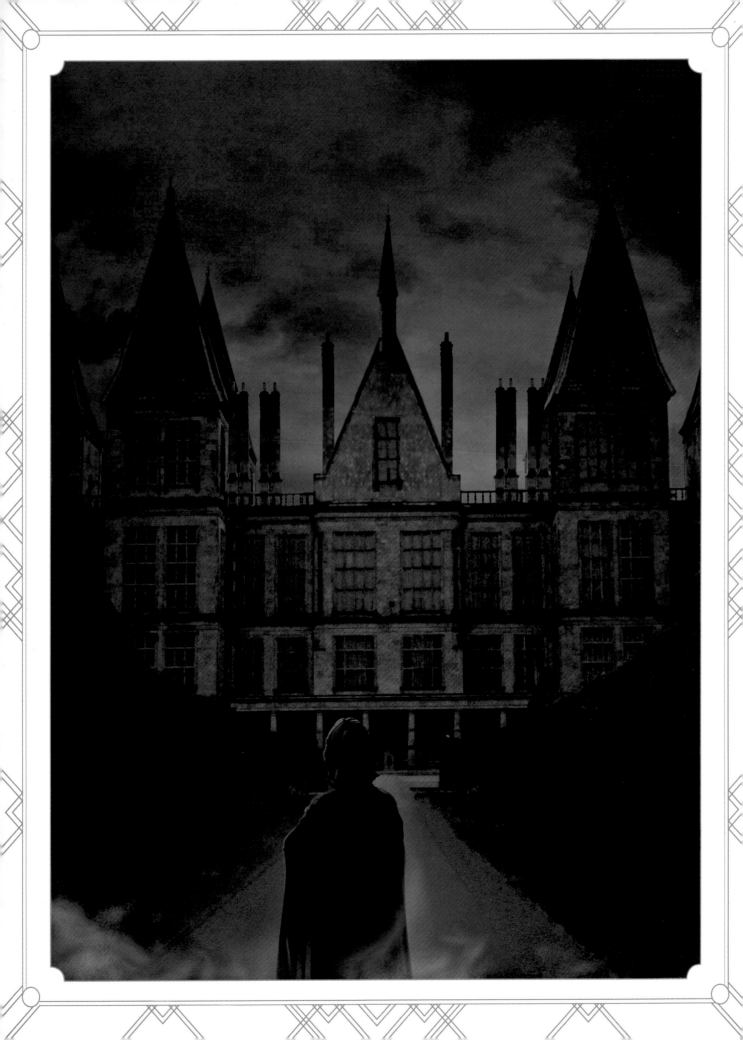

that's invisible to the rest of the world." While the countryside used as a background for The Burrow is set near the coast of southern England, the Lovegood residence is placed against the moorlands of Grassington, a village in Yorkshire three hundred miles to the north. "Nonetheless the two are compatible, and you can believe that one is just over the hill from the other," says Craig.

Other wizarding homes are nestled among Muggle residences. One of the oldest of wizarding families, the Noble and Most Ancient House of Black, settled within a posh residential district of inner London, though they did "hide" their terraced townhouse within the row of attached buildings. This was the childhood home of Harry Potter's godfather, Sirius. The residents of number eleven and number thirteen, Grimmauld Place would be surprised to discover that there actually is a number twelve, which can only be revealed through a Fidelius Charm. The childhood home of Potions Master Severus Snape is not so much hidden but is definitely anonymous within a neglected mill town on a road named Spinner's End.

"You must deliver the narrative and tell the story," says Stuart Craig about choosing the settings and architectural styles of wizarding residences. "And it takes a team effort. Early designs are shown and talked about. Models are made, concepts are discussed, and in the conceiving of any set, everything is changeable." Craig always endeavored to start with a strong idea. "And I tried to win arguments and discussions to retain the strength of that idea, not let it get too diluted. But there are always trade-offs," he adds with a smile. "'Well, we can't do *that*, but we can do *this*.' Designing these homes was an elaborate, enjoyable process, absolutely."

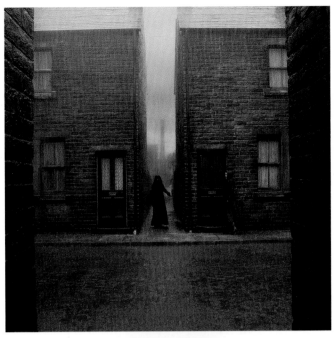

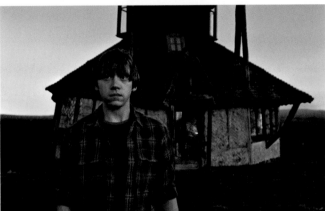

OPPOSITE: *Severus Snape approaches Malfoy Manor in concept art by Andrew Williamson for* Harry Potter and the Deathly Hallows − Part 1. TOP RIGHT: *Film still of Spinner's End,* Harry Potter and the Half-Blood Prince. RIGHT: *Ron Weasley (Rupert Grint) stands outside The Burrow in* Harry Potter and the Deathly Hallows − Part 1. BELOW: *Concept art of The Burrow by Andrew Williamson.*

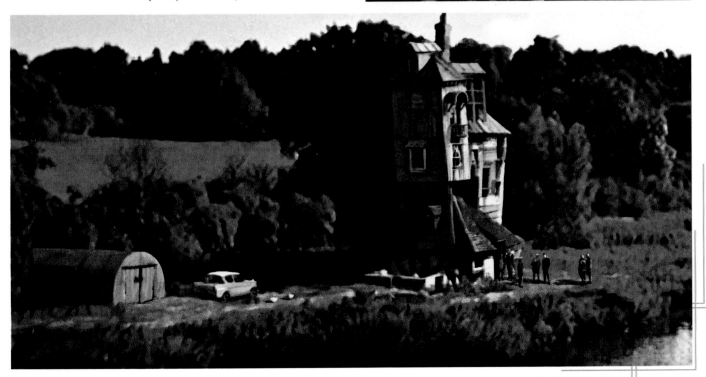

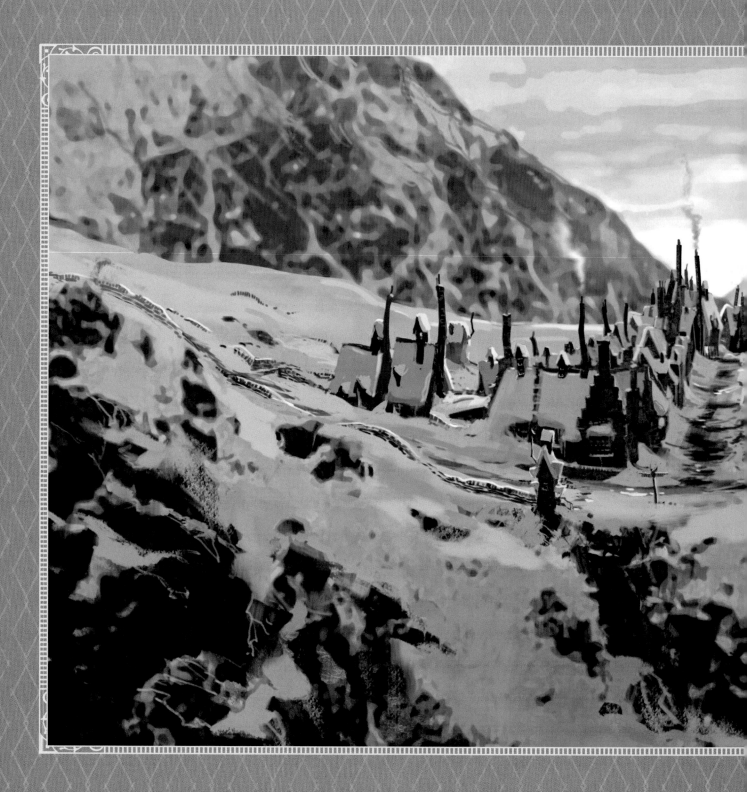

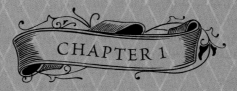

CHAPTER 1

WIZARDING VILLAGES

Professor McGonagall, *Harry Potter and the Prisoner of Azkaban*

HOGSMEADE VILLAGE

PAGES 10–11 AND TOP:
Concept art of Hogsmeade village by Andrew Williamson. OPPOSITE: *Construction plans (bottom right) show the slope of a Hogsmeade street, also seen in a very realistic model (bottom left).*

A trip to the village of Hogsmeade is the first "field trip" allowed away from Hogwarts, and only third-year and older students can go. Harry Potter and his fellow third-years visit it for the first time in *Harry Potter and the Prisoner of Azkaban*, although Harry has to use a secret tunnel to Honeydukes to get there.

Stuart Craig envisaged the village of Hogsmeade as being firmly rooted in the Scottish Highlands. In order to give the village a distinctive theme and feel, Craig set Hogsmeade above the snow line. "That gave it a remote feeling. Every time we see Hogsmeade, it is covered in snow." Craig's artistic decision brought to cinematic life the description that author J. K. Rowling wrote in *Prisoner of Azkaban*: "Hogsmeade looked like a Christmas card."

Hogsmeade was actually a redress of the Diagon Alley set. The buildings of Hogsmeade were covered in the granite found in the Scottish mountains, and they displayed the characteristics of seventeenth-century Scottish architecture: steeply pitched roofs bordered by gables called "crow steps"; tiny dormer windows; and tall, skinny chimneys. Though covered in swirling snow, the village has a friendly atmosphere. "I think it is jolly," says Craig. "It's cold and rugged on the outside, but every shop window is warm and inviting and full of magical things, like Butterbeer and great sweets." As the high-altitude double of Diagon Alley, there are little to no right angles to the buildings. "If you have a wooden building and it subsides, you know that the joints in the frame would twist," says assistant art director Gary

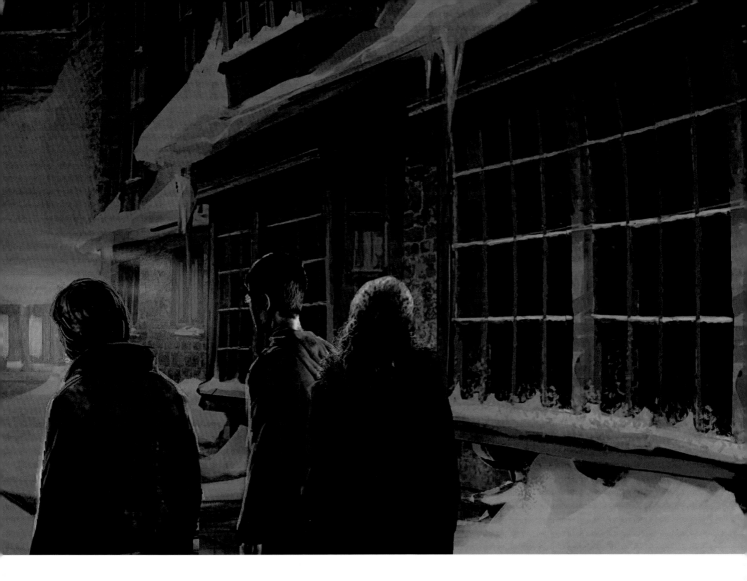

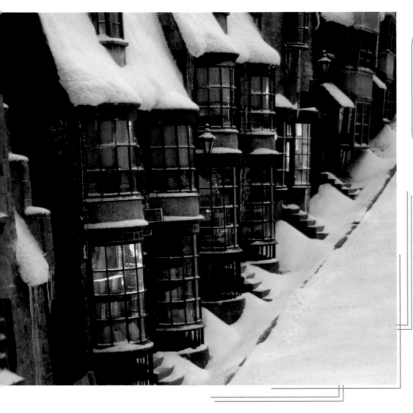

OCCUPANTS: Villagers, Hogwarts students and teachers

FILMING LOCATION: Leavesden Studios

APPEARANCES: *Harry Potter and the Prisoner of Azkaban, Harry Potter and the Order of the Phoenix, Harry Potter and the Deathly Hallows – Part 2*

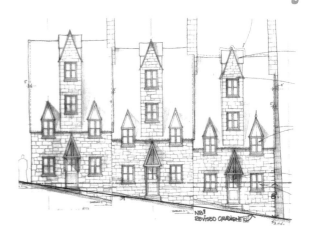

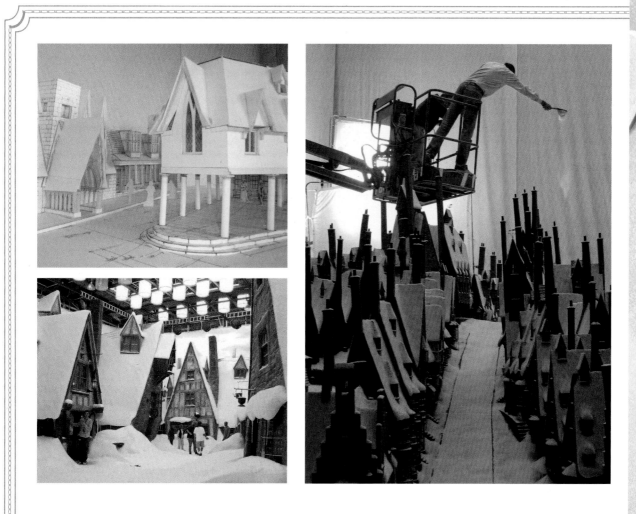

Tomkins. "Stone doesn't do that. With stone it's as if the whole building has subsided." Tomkins and Craig had endless discussions about the behavior of the architecture and if it was going to subside in a way that they wanted. "What manner would the windows tilt, would the doorways shift?" asks Tomkins. "By the end, there wasn't a vertical wall in sight!"

The snow that covers the Hogsmeade buildings and streets consists of dendritic salt, with star-shaped crystals that clump like snow. "It even squeaks like freshly fallen snow when you step on it," adds Tomkins.

This same "snow" fell on a 1/24th scale model of the village, used in quick establishing or long shots, sifted through a tea strainer over the Hogsmeade model from a cherry picker. The model filled out the rest of the village that had not been rendered in full-scale buildings, and it is as detailed as the studio set. Working brass-etched lanterns are placed outside the buildings to light up the street. Inside, the shops are lit by miniscule electric bulbs, which also illuminate the shop windows, filled to the top with goods. There are jars of sweets in Honeydukes and cauldrons piled up

outside the Hogsmeade branch of Potage's Cauldron Shop. Scrivenshaft's Quill Shop features incredibly tiny quills in its windows, and small brooms were produced for Spintwitches sporting goods store. "You'd think we could use doll's house items," says Tomkins, "but there isn't much you can find in owl cages or cauldrons. We made 90 percent of what's in the storefronts." Tomkins would set up a display of props, such as witches' hats or owl cages, take photographs, reproduce these at a smaller percentage, and paste the photo on cardstock, which was then placed inside the tiny bow windows. Tomkins also "populated" the Hogsmeade street. "We made up two sticks with little feet to scale," he explains, "and then 'walked' footprints through the snow coming out of some of the doors and going up the street. We even made up some dog footprints to appear as if someone walked a dog through the village!"

THIS PAGE, CLOCKWISE FROM TOP LEFT: *A white card model of Hogsmeade; dendritic salt, a common movie stand-in for snow, was drizzled over the Hogsmeade sets and models; the film crew on the Hogsmeade set.* RIGHT: *Concept art shows a street view of Hogsmeade with the Shrieking Shack looming in the background.*

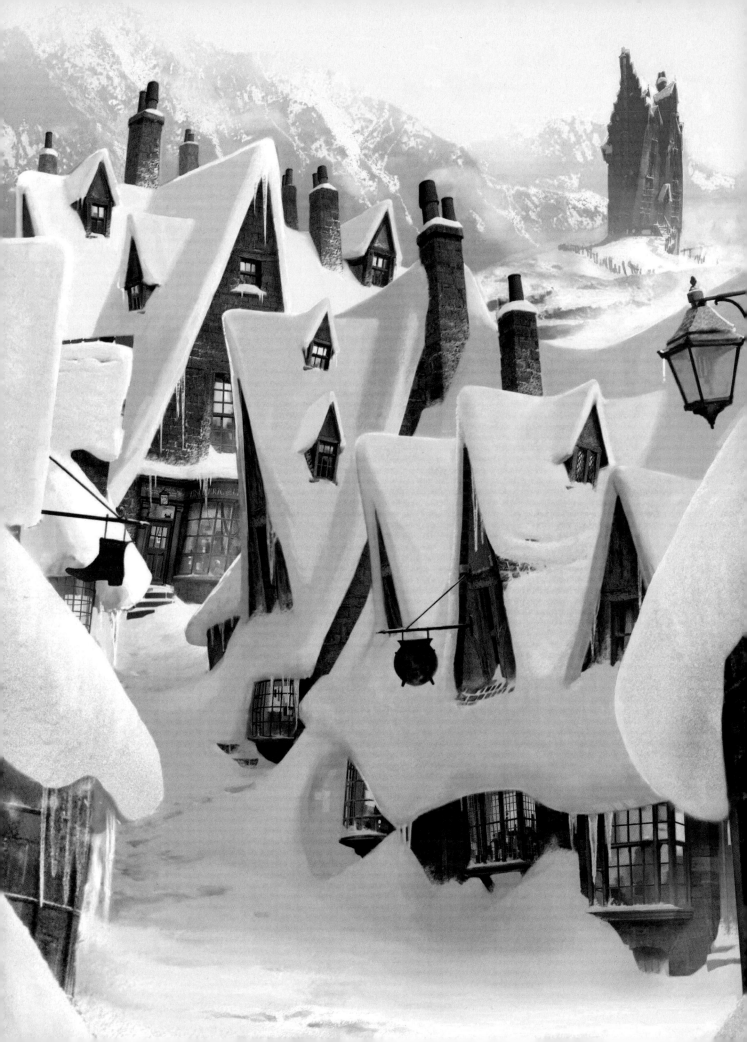

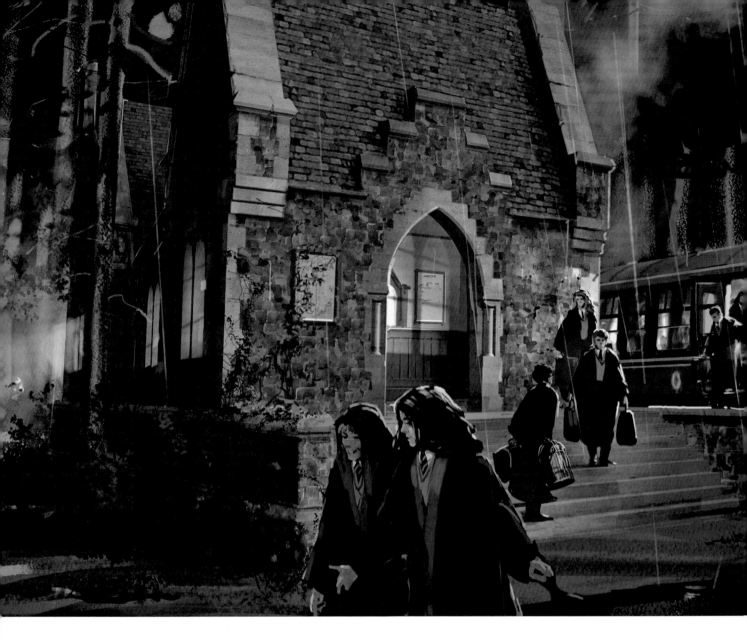

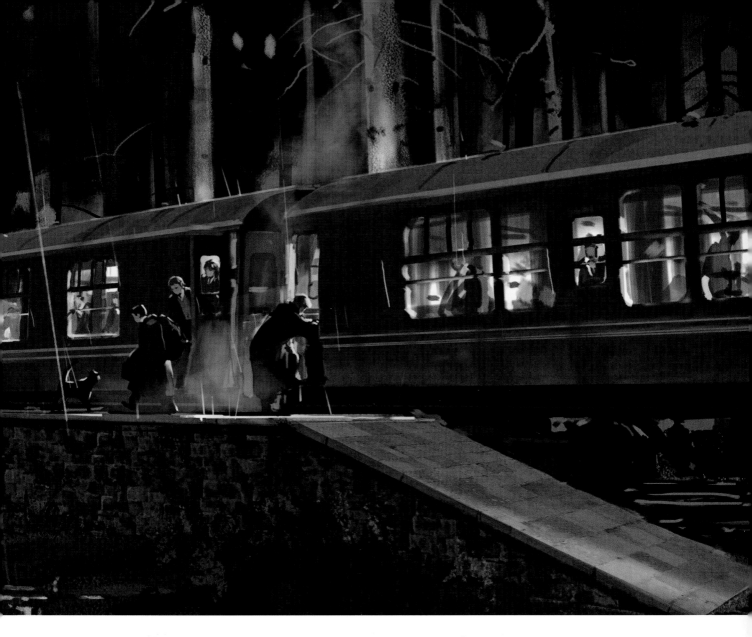

HOGSMEADE STATION

Hogsmeade Station is the arrival and departure point for Hogwarts students riding the Hogwarts Express. In *Harry Potter and the Sorcerer's Stone*, Hagrid greets the new first-year students here, and then, at the end of the film, he sees them back onto the Hogwarts Express for the summer. The *Sorcerer's Stone* scenes were shot at the Goathland village station, part of a popular heritage train line run by the North Yorkshire Moors Railway. The station, built in 1865, required very few changes beyond altering the station's signs and digitally inserting the castle into the background to bring it into the wizarding world. For its appearance in *Harry Potter and the Order of the Phoenix*, where the students disembark and transfer to the Thestral-pulled carriages, the station and a section of track were re-created in Black Park, a location used throughout the films to represent the Forbidden Forest.

OCCUPANTS: Passengers on the Hogwarts Express

FILMING LOCATIONS: Goathland village station, North Yorkshire, England; Black Park, Buckinghamshire, England

APPEARANCES: *Harry Potter and the Sorcerer's Stone, Harry Potter and the Order of the Phoenix*

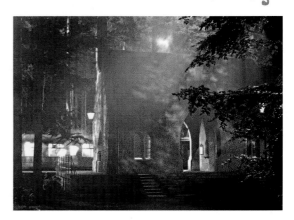

TOP AND OPPOSITE BOTTOM: *Concept art depicts the arrival of Hogwarts students at Hogsmeade Station.* RIGHT: *A view of Goathland station.*

THE SHRIEKING SHACK

The Shrieking Shack is a rickety, juddering structure set on a hill near Hogsmeade village. During the events of *Harry Potter and the Prisoner of Azkaban*, it is discovered that the building was created to house Remus Lupin during his transformations into a werewolf during his time as a Hogwarts student.

Stuart Craig knew that the iconic Shrieking Shack had to have a character of its own. "It needed to be creaking and moving, as if being continually buffeted by the wind," he says. He enlisted the help of special effects supervisors John Richardson and Steve Hamilton to construct the set. First, a miniature model was created to determine the building's movement. Then the full-size set was built on a hydraulic platform, as a structure within a structure. "It had a massive steel frame," Craig explains, "that was pushed around by the hydraulics. Then we built the set to hang on to the frame." Because of the amount of sway, the movement was not confined to just the walls: "The door swings back and forth,

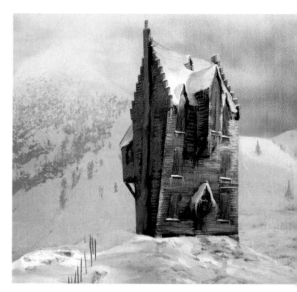

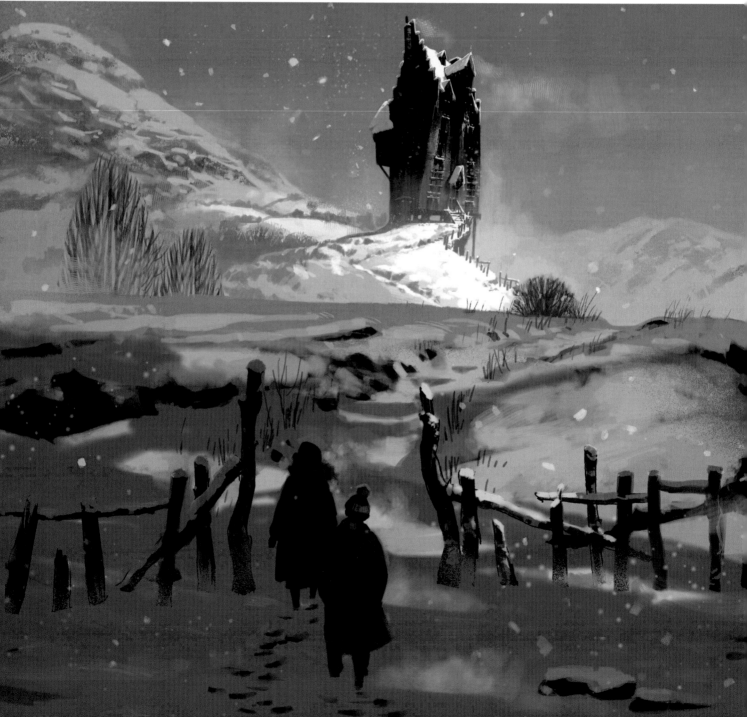

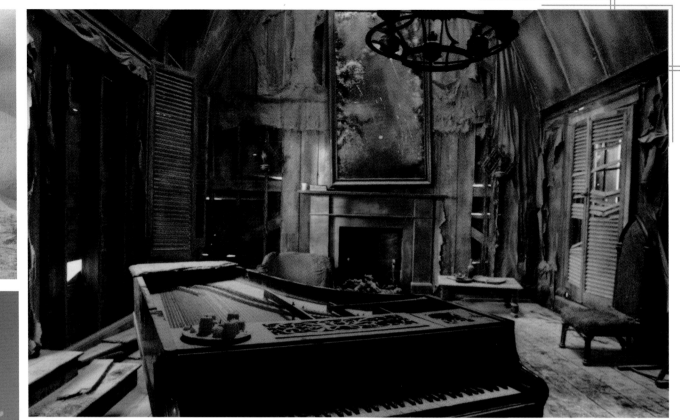

the shutters swing back and forth, the wall fabric kind of flaps. . . . the whole room literally moves." Director Alfonso Cuarón adds, "It was Stuart's idea that everything is shaking and everything is swaying. So it was a huge set that was built with this structure that allowed the whole construction to be tilting back and forth, squeaking all the time, and the walls moving back and forth. Some people got motion sickness just because of the walls moving like that!"

Craig was also influenced by Remus Lupin himself. "The journey to the Shrieking Shack is meant to represent the terrible journey Lupin endures during his transformation into a werewolf," he says. The room, which he presumed was furnished out of Hogwarts furniture, is decimated and reflects Lupin's inner torment. "He has this once rather splendid bed, now completely wrecked and completely dilapidated. To me, this room was designed to represent the history of these terrible transformations, the terrible agonies, and the violence and the damage that he wrought upon the place." The hard work of Craig and his team met the challenge of the complicated construction and detailed design, and that contributed to the shack's emotional resonance.

The shack also presented challenges to the director and the actors. Alfonso Cuarón explains, "Everything was supposed to be dusty. So, for the first take, everything is dusted, and we do the take. When we go to take two, we have to dust everything again because you see everyone's footprints. And again, take after take." Daniel Radcliffe (Harry Potter) recalls that, "The creaking of the walls was so loud sometimes we couldn't actually hear what the other was saying."

Craig is proud of the fact that though the audience might not see it, they can feel the layers of detail that were used in realizing the shack. "If you look closely, you can see that within the special-effects steel frame there is a wooden frame. There are external boards as well as interior, internal ones. And then the whole thing is covered in this silk tapestry." He believes that ever-improving technology justifies this attention to detail. "I think that in any era of moviemaking, what you half-saw and what you half-understood always played a part. But in these days of DVDs, where viewers are able to stop a film frame and analyze it, no detail is wasted in my view."

OCCUPANTS:
The Marauders
(Remus Lupin, James
Potter, Sirius Black,
Peter Pettigrew)
APPEARANCE: *Harry
Potter and the Prisoner of
Azkaban*

THESE PAGES, CLOCKWISE FROM TOP LEFT: *A model was constructed of the Shrieking Shack exterior; the living room set as seen in Harry Potter and the Prisoner of Azkaban; concept art by Adam Brockbank shows Ron and Hermione approaching the Shack.*

THE HOG'S HEAD

To convince potential members to pledge to the newly established Dumbledore's Army in *Harry Potter and the Order of the Phoenix*, Hogwarts students gather in Hogsmeade's Hog's Head pub, a slightly seedy place that Hermione Granger believes will offer them privacy. Entering the establishment, the students can't help but notice its namesake at the entrance—a large hog's head mounted on the wall that rolls its eyes, snuffles its nose, and dribbles "profusely," according to Nick Dudman, creature effects supervisor and special makeup effects artist. The head is operated by a performer behind the wall. "It's a comic aside," he explains. "And those are always a pleasure to do, even if it's a one-off gag that will just help a scene along or give you a diversion for a minute." Though the gag is seen only fleetingly on-screen, Dudman and his team gave as much attention to the animatronic creation as to any other creature in the films. "There's actually a lot of time that goes into creating something like this. It has to be sculpted and molded, then the skin is produced in silicone, and then it's painted." The most time-consuming aspect was inserting every single hair individually into the head. "But," he adds, "that gives it an air of realism you really can't achieve any other way."

The Hog's Head is an exaggeration of a typical London pub. But it leans more than any real pub ever could," notes Stuart Craig. "The oak beams are heavier, it's more decrepit, and the wood is more worm-eaten than hopefully you would ever find in a real pub."

Harry, Ron, and Hermione find shelter in the Hog's Head during the events of *Harry Potter and the Deathly Hallows – Part 2* as they attempt to return to Hogwarts to find the remaining Horcruxes.

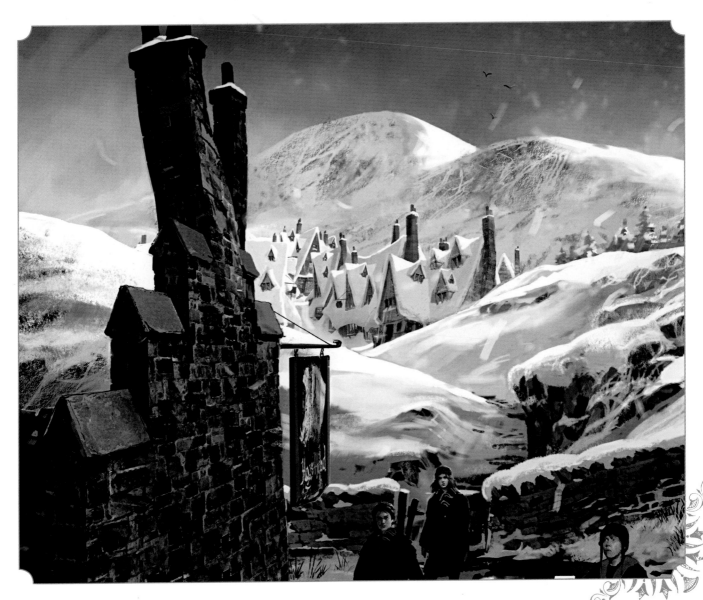

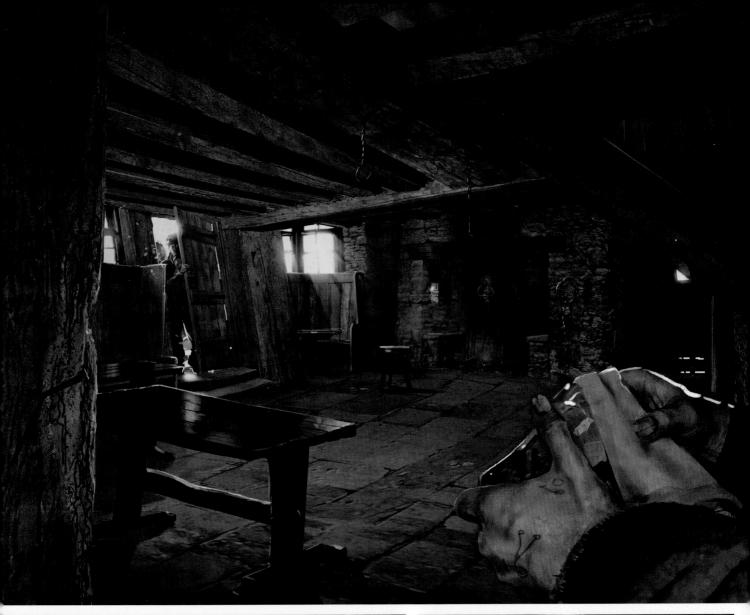

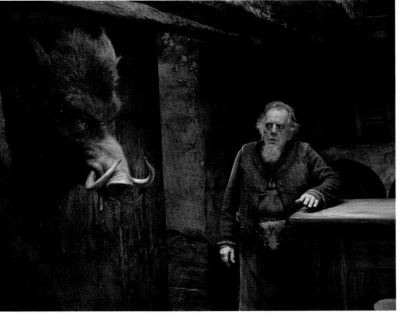

THESE PAGES, CLOCKWISE FROM TOP LEFT: *The design of the animatronic hog's head; art by Andrew Williamson shows a view from the bartender's perspective; Neville Longbottom (Matthew Lewis) emerges from behind a portrait of Ariana Dumbledore in* Deathly Hallows – Part 2; *the hog's head as seen in* Harry Potter and the Order of the Phoenix; *art by Andrew Williamson.*

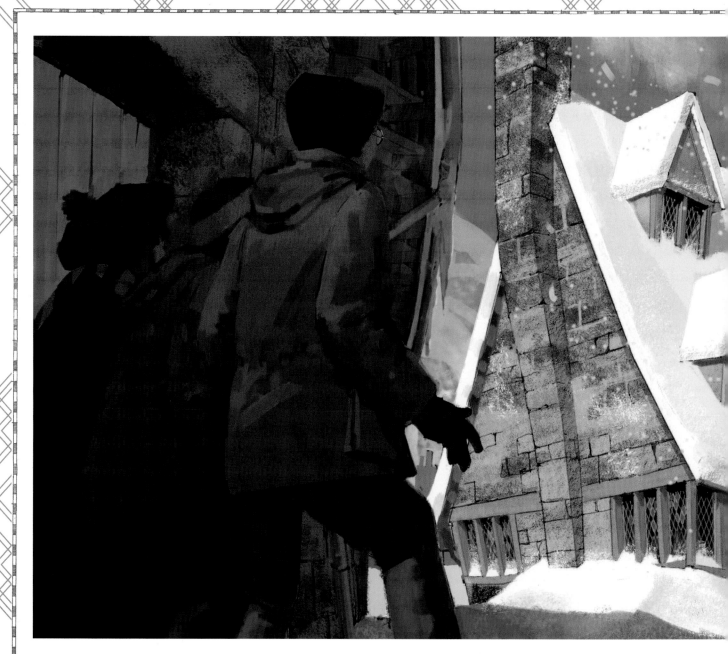

OCCUPANTS: Madam Rosmerta,
Hogwarts students and professors

FILMING LOCATION: Leavesden Studios

APPEARANCES: *Harry Potter and the
Prisoner of Azkaban, Harry Potter and the
Half-Blood Prince*

TOP: *In art by Andrew Williamson,
Harry, Ron, and Hermione follow
Hagrid and Professor McGonagall to the
Three Broomsticks.* OPPOSITE: *Photos
of the Three Broomsticks interior set.*

THE THREE BROOMSTICKS

The Three Broomsticks is seen briefly in *Harry Potter and the Prisoner of
Azkaban*, when Harry Potter (covered by his Invisibility Cloak) follows
Professor McGonagall, Minister for Magic Cornelius Fudge, and Madam
Rosmerta upstairs and secretly listens as they discuss Sirius Black. The room
where they meet mirrors the Tudor-style carved wood walls of the Leaky
Cauldron. In fact, the Three Broomsticks could be Hogsmeade's counterpart
to the Leaky Cauldron, with the added decoration of mounted stuffed animal
heads.

 The Three Broomsticks is all about the details, with no flagon unturned.
There are casks of Butterbeer, jugs, and pint glasses. Under a broad-beamed arch, a
huge fireplace roars at one end of the room, the wall above it adorned with trophies
bearing all sizes of antlers. There is even a small bell on the bar used for the
traditional ring announcing the last drink of the night. The graphics department
provided labels for the inn's beverage offerings, including Blishen's Firewhisky and
Dragon Barrel Brandy, and they labeled the bar food, which would be popular in
both the wizarding and Muggle worlds: Black Cat Potato Crisps and the Three
Broomsticks–produced famous Spellbinding Nuts (roasted on-site).

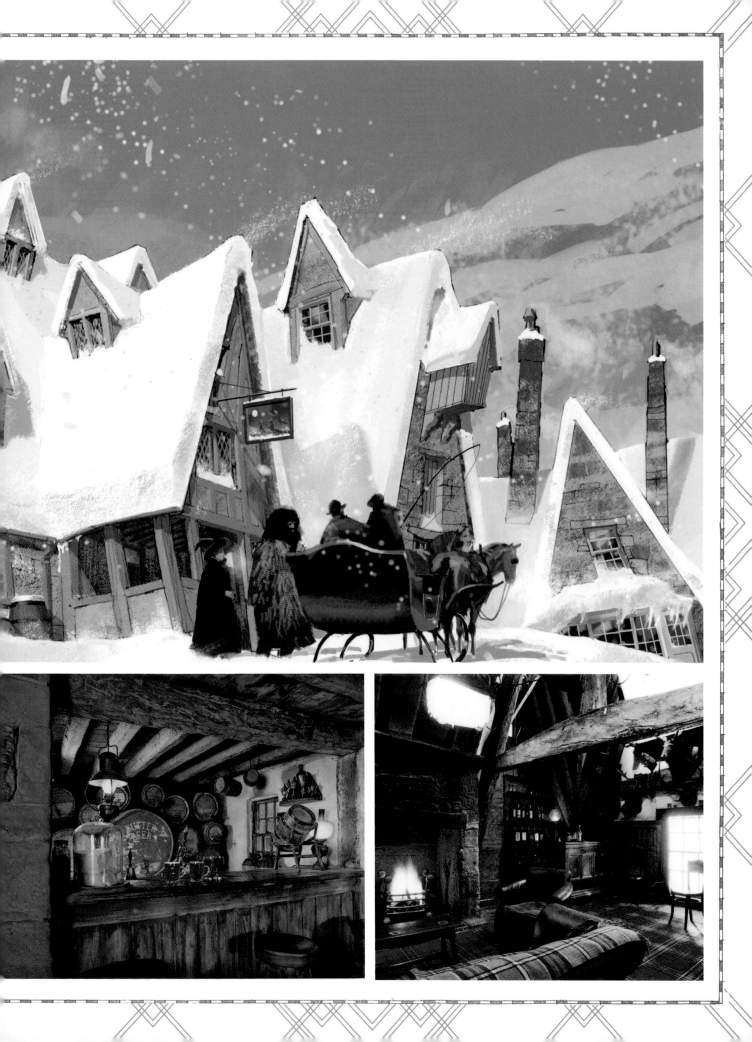

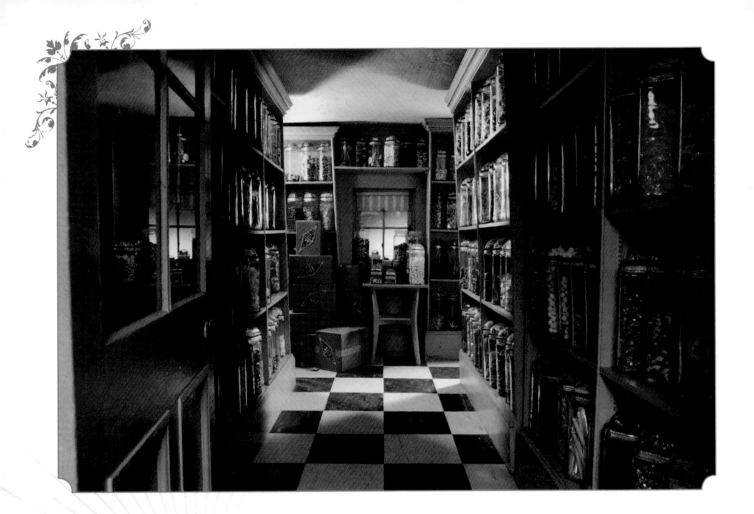

HONEYDUKES

Filled to the rafters with candy, Honeydukes Sweetshop is well known to children of the wizarding world. Honeydukes was placed in what was originally Ollivanders and then Flourish and Blotts in the redresses of Diagon Alley. Honeydukes is stacked floor to ceiling with candy, including glass columns filled with Bertie Bott's Every-Flavour Beans and rows of Chocolate Frogs. The décor is as colorful as its products, with shelves painted peppermint green with accents of cotton-candy pink, and Ice Mice race up and down the walls. Graphic designers Miraphora Mina and Eduardo Lima created the packaging for myriad merchandise, which ranges from melt-in-the-mouth Glacial Snow Flakes and Tooth Splintering Strong Mints to Madam Borboleta's Sugared Butterfly Wings and Limas Crazy Blob Drops. The prop department churned out racks of chocolate skeletons, and as a nod to director Alfonso Cuarón's Mexican heritage, there are rows of *calaveras*, the vibrantly decorated skull-shaped sugar candies traditionally made for Day of the Dead celebrations. In order to prevent the actors from eating up all the props, they were warned that the candy had been covered with a lacquered finish, which was actually a well-intentioned fib.

"HONEYDUKES SWEETSHOP IS BRILLIANT."

Ron Weasley, *Harry Potter and the Prisoner of Azkaban*

OCCUPANTS: Honeydukes customers

APPEARANCE: *Harry Potter and the Prisoner of Azkaban*

THESE PAGES: *Photos of the colorful Honeydukes set taken for* Harry Potter and the Prisoner of Azkaban.

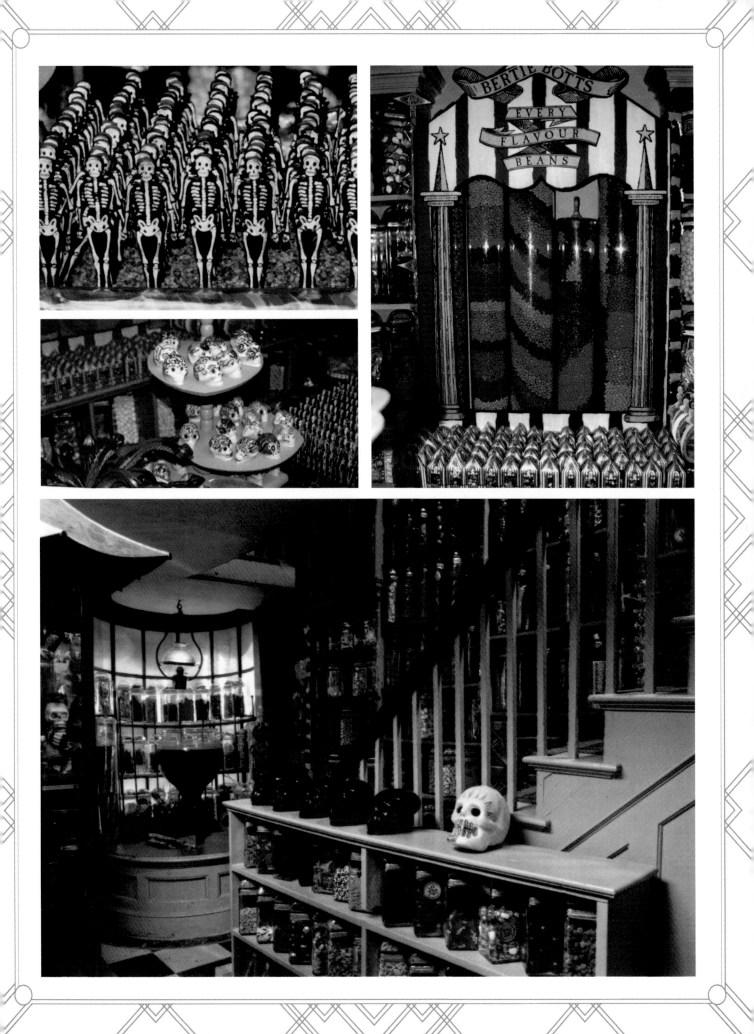

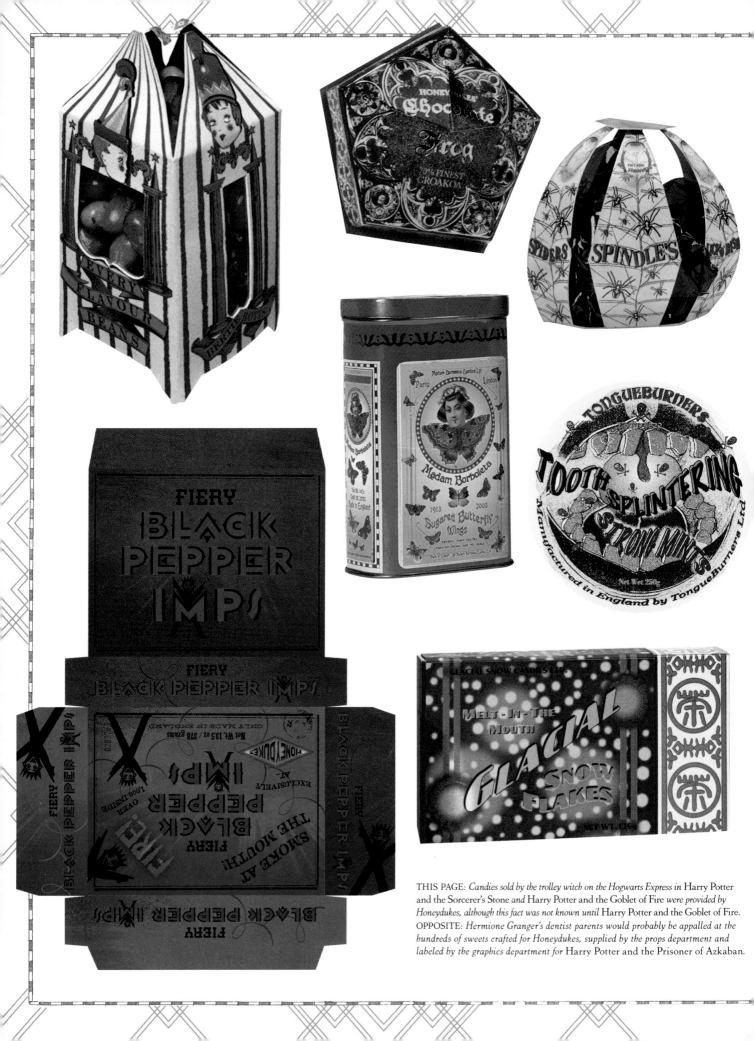

THIS PAGE: *Candies sold by the trolley witch on the Hogwarts Express in* Harry Potter and the Sorcerer's Stone *and* Harry Potter and the Goblet of Fire *were provided by Honeydukes, although this fact was not known until* Harry Potter and the Goblet of Fire. OPPOSITE: *Hermione Granger's dentist parents would probably be appalled at the hundreds of sweets crafted for Honeydukes, supplied by the props department and labeled by the graphics department for* Harry Potter and the Prisoner of Azkaban.

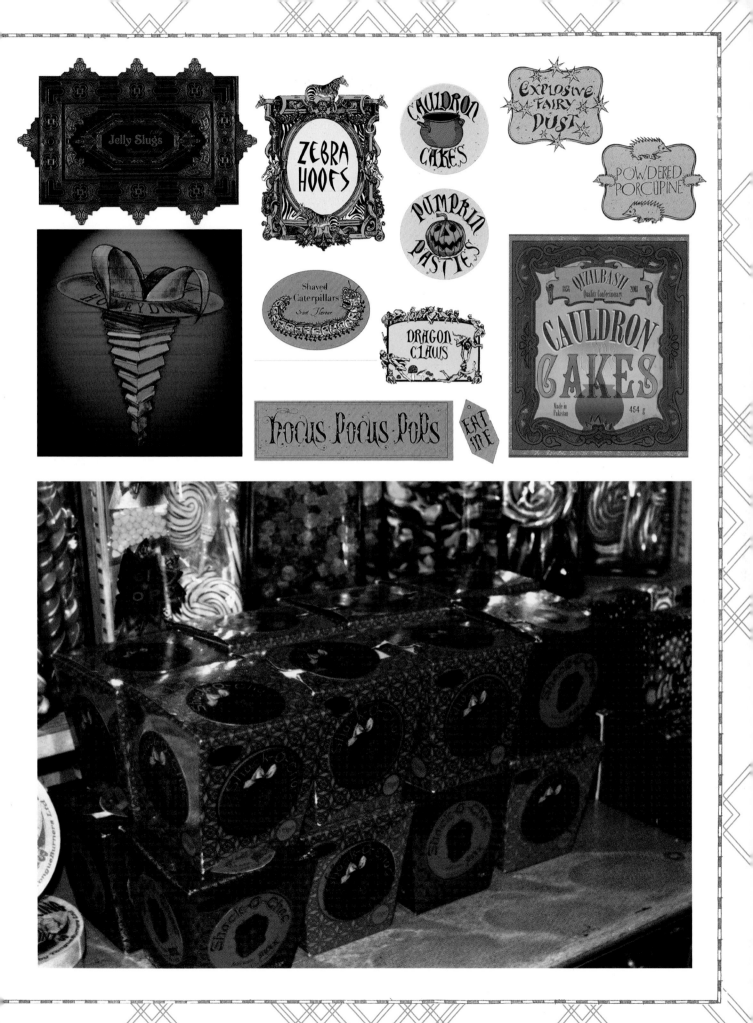

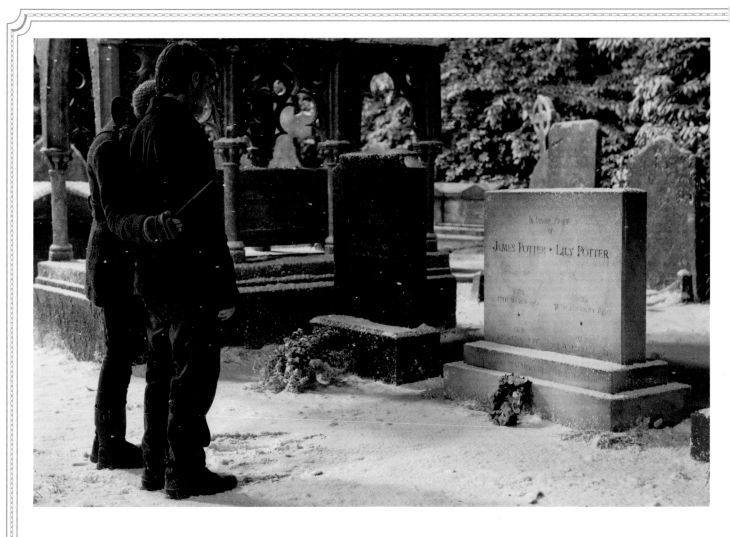

GODRIC'S HOLLOW

The house of James and Lily Potter is seen briefly in *Harry Potter and the Sorcerer's Stone*, and later, Harry Potter and Hermione Granger travel to the small village in their pursuit of Horcruxes, in *Harry Potter and the Deathly Hallows – Part 1*. There, they visit the graves of Harry's parents and the home of Bathilda Bagshot, author of *A History of Magic* and friend of Albus Dumbledore. Production designer Stuart Craig referred back to the Potter house, as well as to descriptions in the books, when he set out to create the entire town. "I wanted to embrace something that was quintessentially English, to contrast with the Gothic style and granite of Hogwarts and Hogsmeade. Godric's Hollow is very much representative of the southern portion of England, designed in the half-timbered style of the Tudor period, with brick and plaster façades." Craig and locations manager Sue Quinn looked for a country village that might portray the Hollow and found Lavenham, in Suffolk, which is packed with fifteenth-century half-timbered houses. "It is one of the most spectacular, most beautiful of the rich Suffolk villages," says Craig. Despite this, the decision was made to

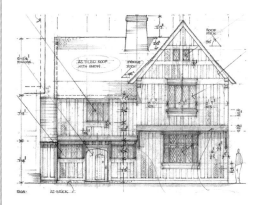

"I WANT TO GO TO GODRIC'S HOLLOW. Y'KNOW IT'S WHERE I WAS BORN, IT'S WHERE MY PARENTS DIED."

Harry Potter, *Harry Potter and the Deathly Hallows – Part 1*

OCCUPANTS: James, Lily, and Harry Potter; Bathilda Bagshot; Albus, Aberforth, and Ariana Dumbledore

FILMING LOCATIONS: Lavenham, Suffolk, England; Pinewood Studios

APPEARANCE: *Harry Potter and the Deathly Hallows – Part 1*

shoot the sequence on a studio lot, though not at Leavesden. "Pinewood Studios has this splendid old garden, part of the original estate before it was ever a studio," he explains. "And there is a magnificent cedar tree there." He envisioned the graveyard in Godric's Hollow underneath the spreading branches of the tree, so the churchyard, the church, and the rest of the village was built around it." The Godric's Hollow church had specially created stained-glass windows, and the entrance to the churchyard is a roofed lych-gate. There are also two streets and an inn, along with the Potter's ruined cottage and Bathilda Bagshot's house, where Harry encounters Voldemort's serpent, Nagini. Craig researched what he refers to as traditional British churchyard cemeteries, "but there is exaggeration in ours. The stones are more monumental than you would find in a typical cemetery." The physical set was extended digitally with views of Lavenham, and the entire set was covered in snow. Daniel Radcliffe has said that filming the scene was "very, very emotional."

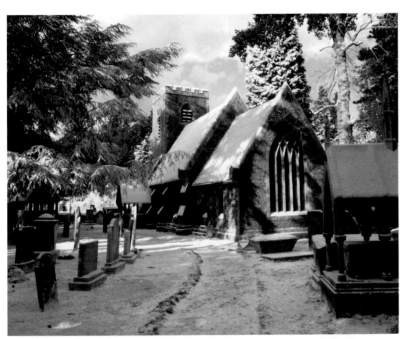

THESE PAGES, CLOCKWISE FROM TOP LEFT: *Hermione Granger embraces Harry Potter in front of his parents' gravestone in* Harry Potter and the Deathly Hallows — Part 1; *views of the Godric's Hollow set at Pinewood Studios; building plans used to create the set.*

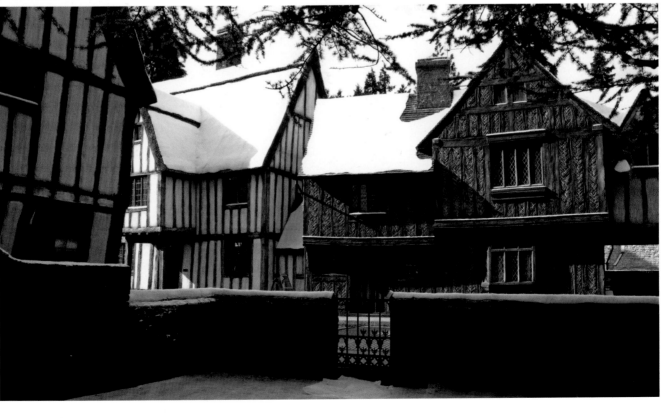

WIZARDING HOMES

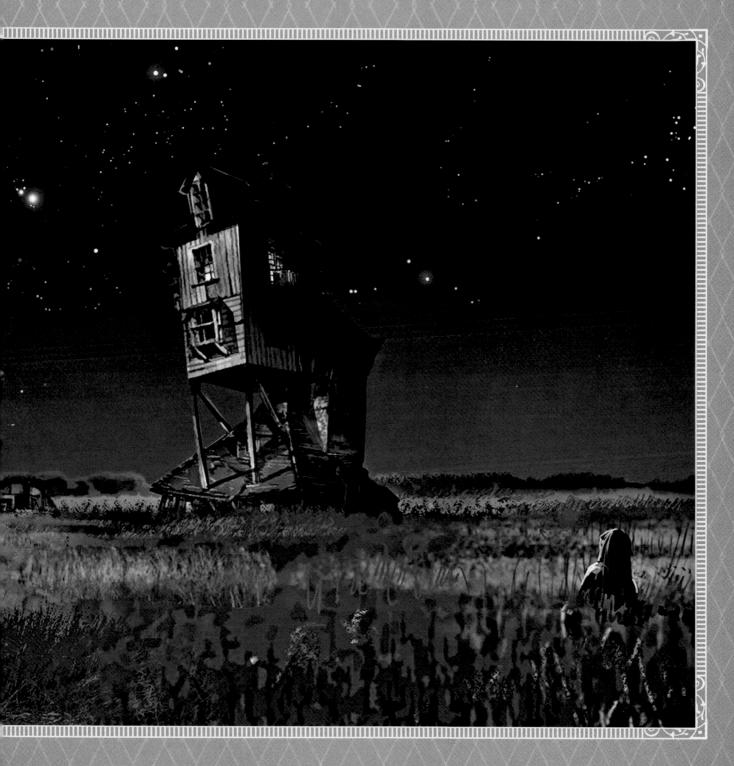

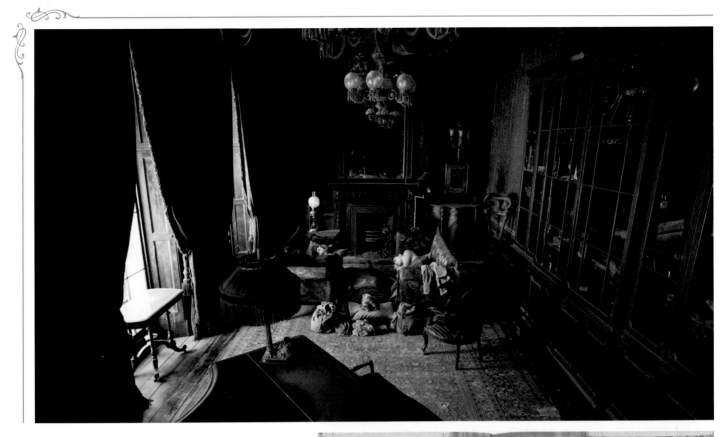

GRIMMAULD PLACE

In *Harry Potter and the Order of the Phoenix*, Harry Potter is escorted by members of the Order of the Phoenix to number twelve, Grimmauld Place, the ancestral home of the Noble House of Black. There he joins the Weasleys, Sirius Black, and others as they discuss plans for stopping Voldemort's army. Magically, number twelve, Grimmauld Place is only visible to those who know it's there. "Grimmauld Place appears from behind a drainpipe," explains Stuart Craig. "It starts with one dimension, then develops out into two dimensions, and then three as the front steps pop forward and the windows sink back." Craig always felt that the natural location for Grimmauld Place would be in one of London's Georgian squares among their early nineteenth-century houses. A physical façade of six townhouses was built at the studio, but the actual emergence of Grimmauld Place was achieved digitally. Then special effects were added to the materialization: a fish tank judders, curtains flutter, and dust spills from the roof.

"The exterior is typical of that time period," he reiterates. "What is atypical, of course, is the way it magically appears. We tried to reflect that on the inside, to have a strangely distorted space. When you open the front door, for example, there's a very compressed hallway." Many of the corridors and the kitchen were created with forced perspective, so they disappear into infinity. Additionally, "Sirius Black is hiding out after his escape from Azkaban," set

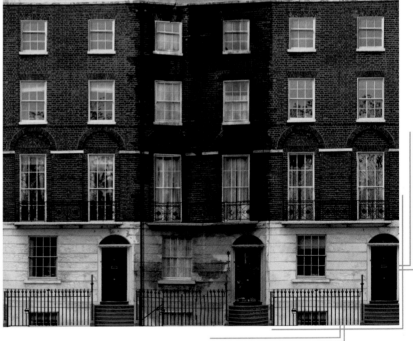

OCCUPANTS: The Black family, the Order of the Phoenix

FILMING LOCATION: Leavesden Studios

APPEARANCES: *Harry Potter and the Order of the Phoenix, Harry Potter and the Deathly Hallows – Part 1*

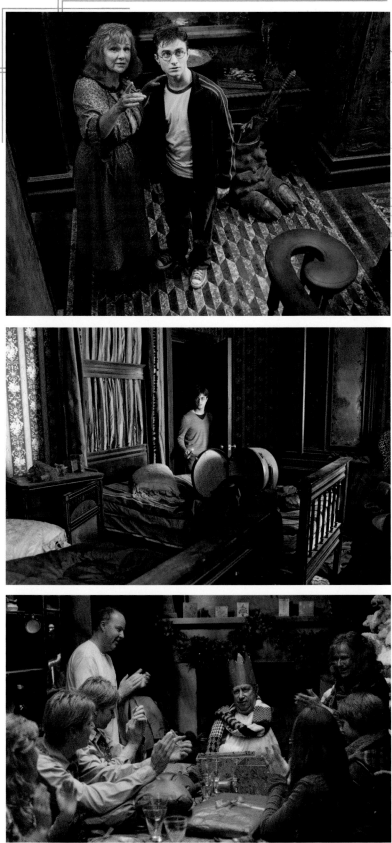

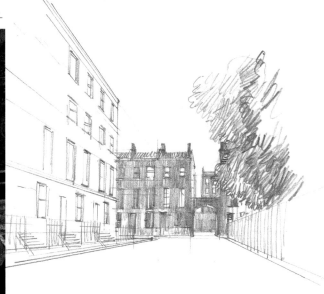

decorator Stephenie McMillan adds, "so there's also the feeling of it being enclosed. Stuart designed it with very high, narrow ceilings. And it has tall, thin windows that are mirrored so that no one can see out, which, again, gives it another effect of enclosure." McMillan complemented the squeezed look with extra-tall wardrobes, dressers, and beds.

Craig chose a blue-black inky color for the palette for Grimmauld Place, so when Stephenie McMillan purchased furniture to fill the house, she had it painted dark ebony, which matched the ebonized wood that makes up the staircases and baseboards. The curtains and wallpaper on the decaying walls were made from more than a thousand feet of dark gray Indian silk, embellished with gold. McMillan assumed that the guest bedroom the kids stay in at the top of the stairs was decorated by the late Mrs. Black, so she dressed the room with black dressers and a curvy well-worn dressmaker's dummy. "I started collecting old fans," she adds, "which I set in black frames, with dead moths inside."

"David Yates wanted the kitchen extended even longer than originally designed," she continues, "which I think was to accentuate Sirius and Harry being apart from the family." McMillan wasn't able to find a table that would run twenty feet down the Black family kitchen, so it was built at the studio. The sides of the kitchen were wild walls to allow for shooting, fronted by thirteen-foot-high sideboards. "They were jammed with old silverware and pewter in a jumbled mess, as Kreacher is looking after the house." There is also a collection of dark-blue-and-gold-rimmed china, with the family crest on it, designed by the graphics department. McMillan added hanging cauldrons and huge teakettles for a homey feel.

PAGES 30–31: *Concept art by Andrew Williamson for* Harry Potter and the Half-Blood Prince *depicts a Death Eater approaching The Burrow on Christmas night.* THESE PAGES, CLOCKWISE FROM TOP LEFT: *The number twelve, Grimmauld Place sitting room was thirty feet long; Molly Weasley (Julie Waters) and Harry Potter in* Harry Potter and the Order of the Phoenix; *Harry enters the guest room in* Harry Potter and the Deathly Hallows – Part 1; *director David Yates on the set as the Weasley family celebrates Christmas in* Harry Potter and the Order of the Phoenix; *the Grimmauld Place façade.*

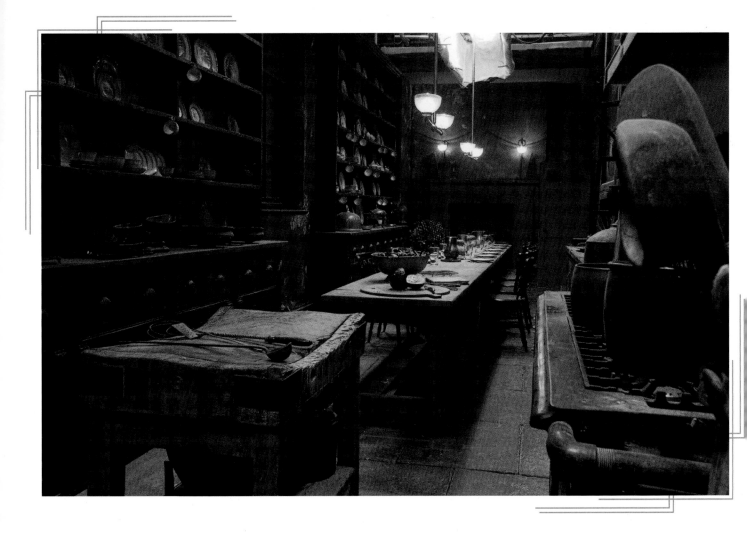

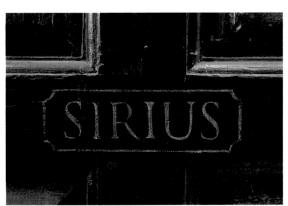

"THIS IS MY PARENTS' HOUSE. I OFFERED IT TO DUMBLEDORE AS HEADQUARTERS FOR THE ORDER."

Sirius Black, *Harry Potter and the Order of the Phoenix*

Harry returns to Grimmauld Place in *Harry Potter and the Deathly Hallows – Part 1* with Ron and Hermione, when they are pursued by Death Eaters. Stephenie McMillan had new challenges. "We had a big drawing room to do, and two bedrooms, Sirius and Regulus Black's bedrooms, which we hadn't had before. The set had been taken down by then, so we had to rebuild it." The black silk eiderdown quilts on their unmade beds were custom-made. McMillan already had in mind what she wanted for the drawing room, where Harry, Ron, and Hermione camp out. "It didn't feel right to have squashy sofas. I wanted Regency style, with straight upholstered backs, and I found them at a rental company. Two absolutely perfect sofas, upholstered in the most disgusting fabric." McMillan asked the owner if he would sell the sofas to her, "which he appreciated, as no one ever rented them out," she says with a laugh. The sofas were reupholstered in an Asian-themed black-and-gold fabric. David Yates asked for a grand piano for the thirty-foot-long room. "So we made a combination music room and sitting room with a fireplace at each end, and one whole long wall with the biggest bookcase I think I ever designed."

THESE PAGES, CLOCKWISE FROM TOP LEFT: *The set of the number twelve, Grimmauld Place dining room and kitchen; the rooms of brothers Sirius (top) and Regulus Black (bottom) are both disheveled but distinctly decorated; the nameplate on the door of Sirius's room.*

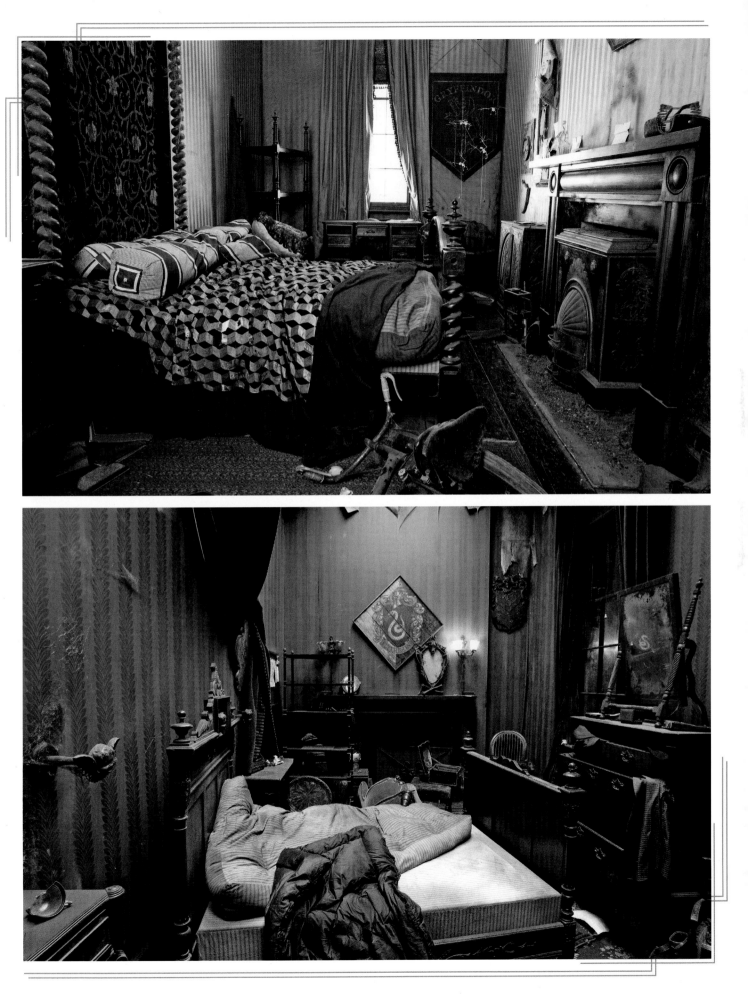

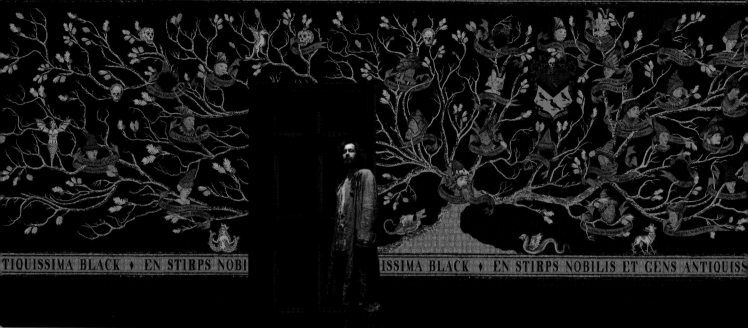

✶ The Black Family Tapestry ✶

The tapestry of the Black family lineage was originally planned to be a vertical wall hanging near the stairs, but its final design was so impressive, the art department reconstructed the Grimmauld Place set and created an entirely new room on the second floor to showcase it. The tapestry stretches from wall to wall. "There is a family tree," says graphic designer Miraphora Mina. "But our job as graphic designers is to present the whole thing, and we didn't know who was related to who." So producer David Heyman called J. K. Rowling. "Jo's knowledge of the world of Harry Potter is so deep. What's in the book is but the surface. I told her we were going to show the Black family tree and asked, 'Do you have any thoughts?'" What he received when the author faxed back some pages to him was five generations of names dated with births, marriages, and deaths, as well as the family crest and motto. Mina drafted the horizontal layout in consultation with Rowling and researched medieval tapestries to populate it: "I looked at a lot of tapestries to find faces that I felt visually lent themselves to be turned into witches and wizards." Then the tapestry's actual creation was discussed. "Early on," recalls Mina, "we met with tapestry makers because there was talk about having it done for real. Thankfully, we did it in the true cinema way, which was to just fake it." Stephenie McMillan located a fabric that mimicked the warp and weft of a woven tapestry, and the images were painted upon it. The disowned relatives of the noble house were burned out, and the fabric was distressed and aged.

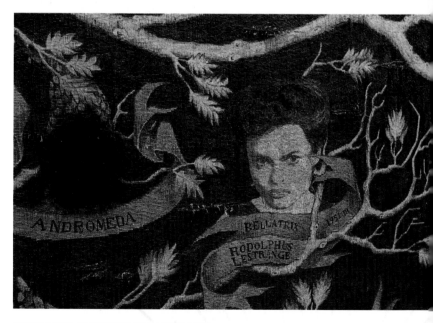

THESE PAGES, CLOCKWISE FROM TOP LEFT:
The Black family tapestry, designed by Miraphora Mina and based on a sketch by J. K. Rowling (a photo of Gary Oldman as Sirius Black has been inserted for scale); Sirius Black embraces Harry Potter in Harry Potter and the Order of the Phoenix; *the tapestry includes burn marks that black out the names of the family members who have been disowned.*

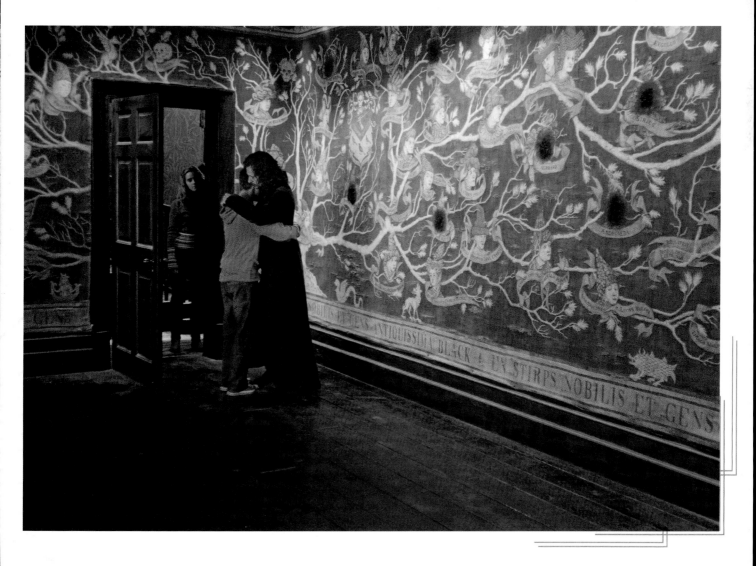

SHELL COTTAGE

"When you see the silhouette of Shell Cottage, it's relatively conventional," says Stuart Craig. "It's a little English cottage. But when you get halfway close to it, you realize it's made out of extraordinary materials." Shell Cottage provides a place for Harry Potter, Hermione Granger, Ron Weasley, Griphook, Ollivander, and Luna Lovegood to recover after their escape from Malfoy Manor in *Harry Potter and the Deathly Hallows – Part 1*. Craig researched houses that had been made with shells but discovered that most had shells stuck in wet cement for decoration. "They weren't structural," says Craig. "I thought it would be more interesting to *construct* it with shells." As always, his desire was to give the house credibility, not a whimsy that might lessen the emotional impact of the sequence. "We used three types of shells," he explains. "The walls were oyster shells, albeit very big ones, that could give it a solidity. We decided that huge scallop shells would make a very good rooftop, able to shed rainwater quite efficiently. And large razor shells would make good ridge tiles. It's still a fantasy building, but you'd believe that it's a plausible structure." The production did cheat slightly: Real shells were molded, then the molds were sculpted up to create the sizes Craig was looking for. Casts were made in a high-density foam and then painted. Forty-five hundred scallop shells were used for the roof alone.

In the novel, Shell Cottage is set on a cliff, but David Yates wanted to incorporate the sound and look of crashing waves and white water, and so a beach location was sought out. The location scouts discovered good beaches all over England, but also looked in Wales, where they chose Freshwater West beach, which had huge sand dunes and, as Craig describes with a laugh, "delivered the best waves." Craig saw the overall setting as delivering something more. "I thought the notion of Shell Cottage set on a sandy beach, with the fact that the sand could drift up and partially bury the house, seemed to have strange melancholy about it."

OCCUPANTS: Bill and Fleur Weasley, Ollivander, Griphook, Luna Lovegood

FILMING LOCATION: Freshwater West, Pembrokeshire, Wales

APPEARANCES: *Harry Potter and the Deathly Hallows – Part 1, Harry Potter and the Deathly Hallows – Part 2*

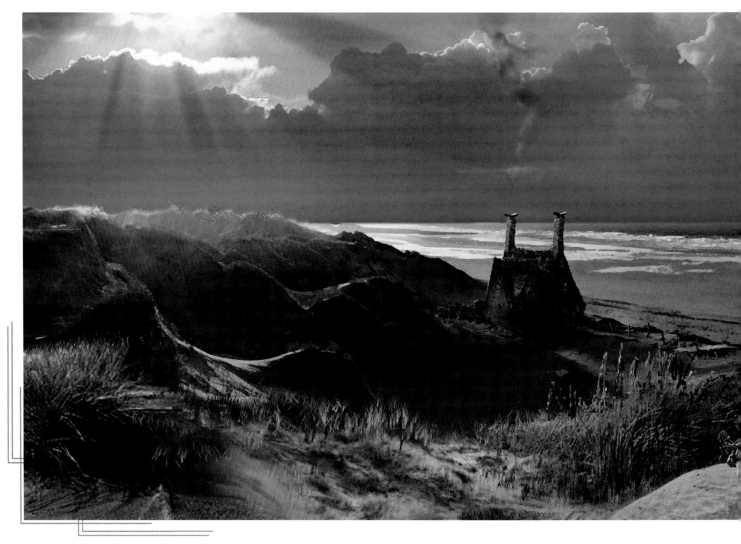

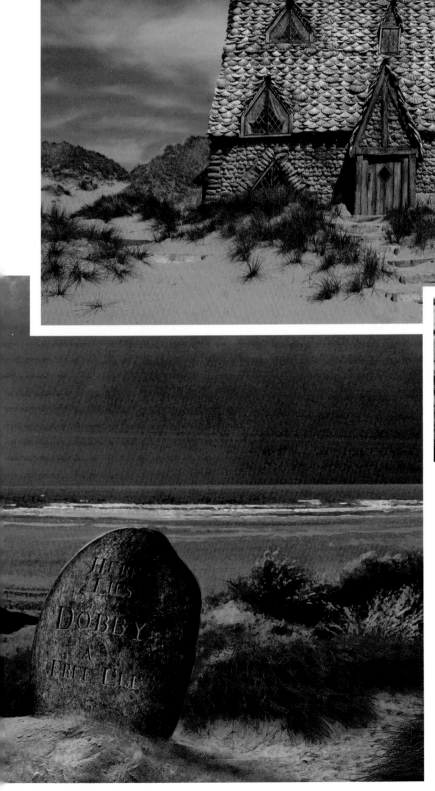

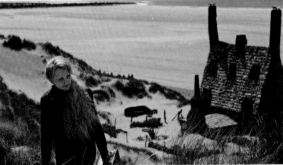

Shell Cottage was prefabricated at Leavesden Studios and then constructed on the beach for exterior shots. Interiors were filmed at Leavesden. "Building on location can be costly," Craig admits, "and just often harder to do. Those waves came at a price in Freshwater, and the price was incredibly high winds. It was really, really difficult to work out there." The winds also affected the stability of the house itself, and to keep it from blowing over, its internal structure was filled with steel scaffolding tubes weighed down with several tons of massive water bottles. "Once done, there was also the frustration of trying to establish continuity with the tide moving in and out twice every twenty-four hours as it does," he remembers. "The beach gave us a few problems, but it gave us drama, too."

THESE PAGES, CLOCKWISE FROM TOP LEFT: *Concept art by Andrew Williamson; the final Shell Cottage exterior, built and then moved to the beach in Pembrokeshire where scenes were shot on location; Luna Lovegood (Evanna Lynch) outside Shell Cottage in* Harry Potter and the Deathly Hallows — Part 2; *concept art by Andrew Williamson.*

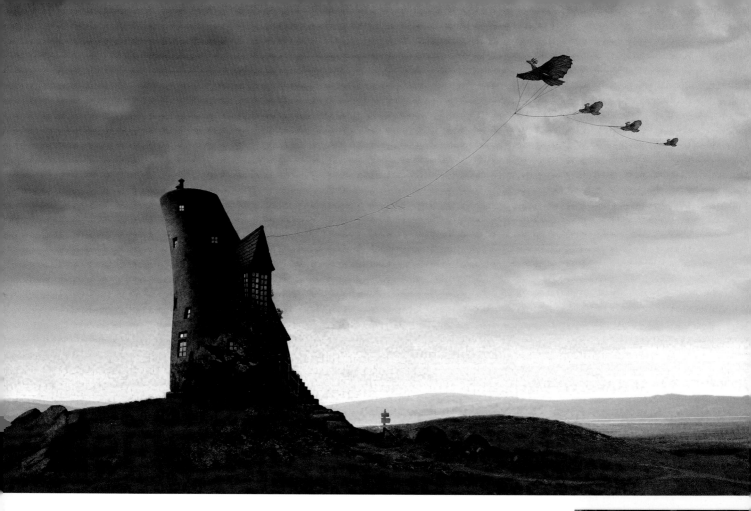

LOVEGOOD HOUSE

The Lovegood house, where Harry Potter, Ron Weasley, and Hermione Granger learn the story of the Deathly Hallows, is where Luna Lovegood's father, Xenophilius, publishes *The Quibbler*, a quirky tabloid newspaper that serves as an alternative to the government-dictated *Daily Prophet*. Evanna Lynch, who plays Luna Lovegood, describes the house as "the perfect sort of place where all those crazy stories would be printed."

"J. K. Rowling depicts it as a black tower, looking like a giant rook, the castle piece in a chess game," explains Stuart Craig. "So there was no room for variance, but as I always try to make a good sculptural shape, the house isn't just a cylinder. It's a cylinder with a very deliberate lean and a very deliberate taper." Inside, the furniture literally takes shape around the circular design. The kitchen appliances, dressers, desks, and bookcases curve flush with the walls, which are covered in paintings by Thomasina Smith, inspired by J. K. Rowling's *Fantastic Beasts and Where to Find Them*, and drawings by Evanna Lynch. "The end result is wonderfully eclectic, but homey," says Stephenie McMillan.

THESE PAGES, CLOCKWISE FROM TOP LEFT: *Concept art by Andrew Williamson of the Lovegood house;* actor Rhys Ifans (Xenophilius Lovegood) confers with Harry Potter and the Deathly Hallows — Part 1 *director David Yates; the Lovegood house interior set; a sketch by Stuart Craig.*

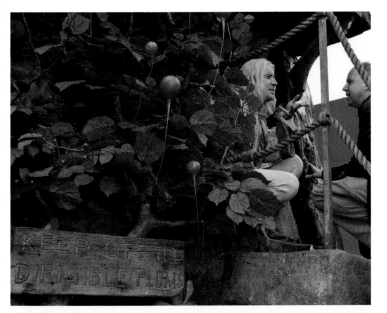

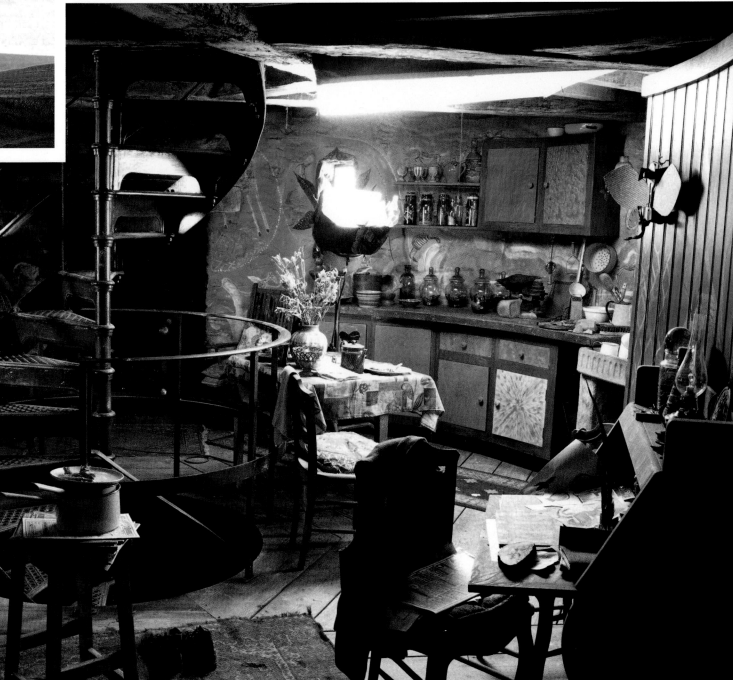

"KEEP OFF THE DIRIGIBLE PLUMS."

Sign outside the Lovegood house,
Harry Potter and the Deathly Hallows – Part 1

OCCUPANTS: Luna and Xenophilius Lovegood

FILMING LOCATIONS: Leavesden Studios;
Grassington, Yorkshire, England

APPEARANCE: *Harry Potter and the Deathly
Hallows – Part 1*

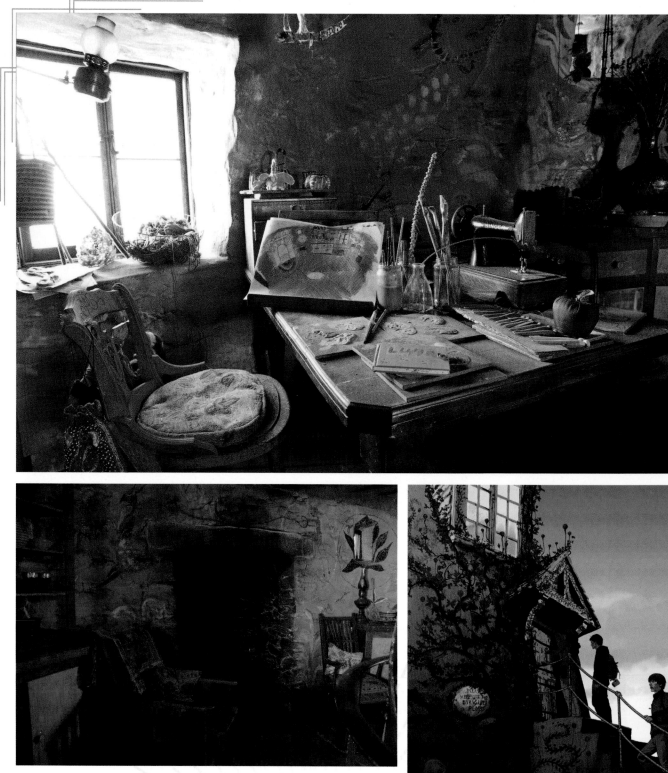

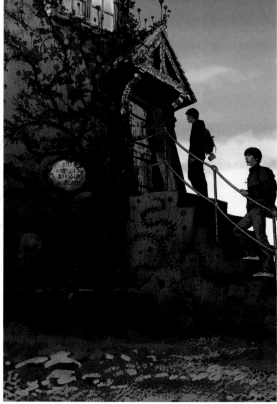

THESE PAGES, CLOCKWISE FROM TOP LEFT: *The interior of the Lovegood house set was designed to appear "lovingly vandalized" by Luna Lovegood; plans for the construction of the exterior of the Lovegood house set; the nineteenth-century printing press that Xenophilius Lovegood uses to print* The Quibbler; *concept art by Andrew Williamson; another view of the house interior.*

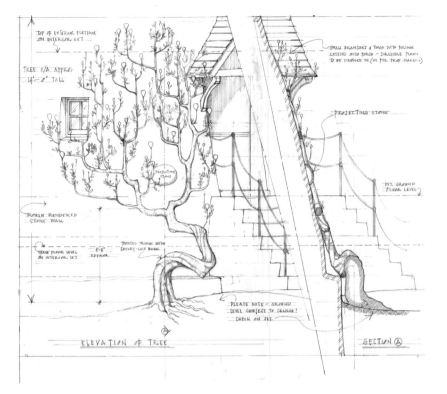

The most important piece of furniture is Xenophilius Lovegood's printing press, which has taken over the main floor, as "maybe only a quarter of his house was living quarters," Stuart Craig explains. The full-sized working machine is modeled on an 1889 American printing press. "And helped by the special effects team," he continues, "we mechanized it further because we thought it would be fun to have the paper on a conveyor belt system, with rollers rushing across the ceiling, up and down the walls, into the guillotine. It was more dynamic, more fun, and more to blow up in the end." Piles of back issues of *The Quibbler* are stacked on the floor around it; the graphics department estimates they printed five thousand copies between the seven issues that were "published." Large, vintage wooden typesetting characters were strewn around the room, loaned to Stephenie McMillan by a print museum located in a small town near the Leavesden Studios.

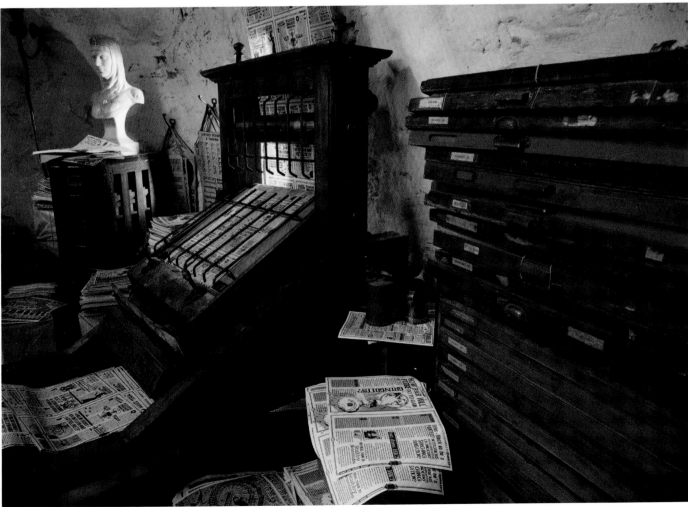

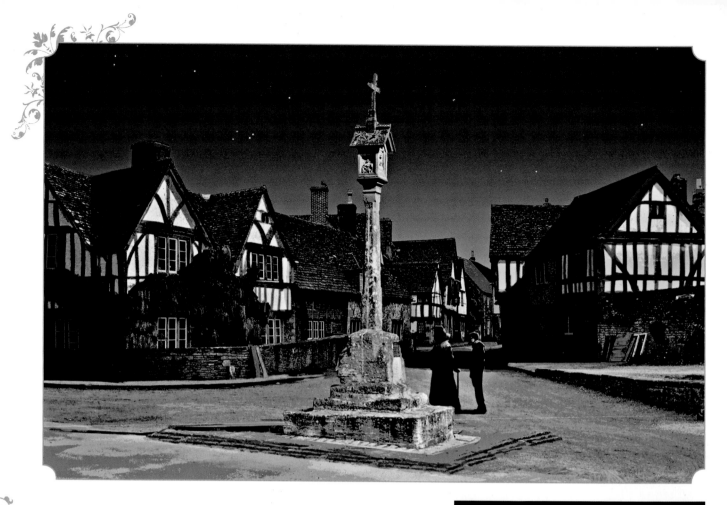

"WELCOME TO THE CHARMING VILLAGE OF BUDLEIGH BABBERTON."

Professor Dumbledore, *Harry Potter and the Half-Blood Prince*

BUDLEIGH BABBERTON

Professor Dumbledore brings Harry Potter to Budleigh Babberton at the beginning of *Harry Potter and the Half-Blood Prince*, where Horace Slughorn, the former Hogwarts Potions professor, is hiding in a Muggle's house to avoid being discovered by the Dark forces. Whilst not strictly a "wizarding home," the measures that Slughorn has taken to hide himself further, assuming the form of a lilac-striped armchair, are well beyond the means of standard Muggle security! When Dumbledore pokes the chair with his wand, it transforms back into the professor, played by Jim Broadbent. For the design team, the first challenge was finding a fabric that could serve as both upholstery and pajamas. "We looked for material that could serve as clothing first," explains costume director Jany Temime. "And when we found it, enough was purchased to create the pajamas and cover the chair. I also found some cord that could be used as clasps for the jacket top and piping for the chair." Special effects supervisor Tim Burke then took over. "We talked it through with David Yates, and realized that our approach should be to have Jim Broadbent play an armchair. A rig was created, sort of like a seesaw, that he could sit on in an armchair-like position and then allow him to rise up and deliver his performance, which is him coming out of an armchair." At the correct moment in the scene, the rig was raised and lifted the actor, who then only needed to "shake" himself out. Part of the transformation from chair into pajamas was also animated digitally. Stephenie McMillan took her cue from Slughorn's pajamas to create a complementary palette for the room.

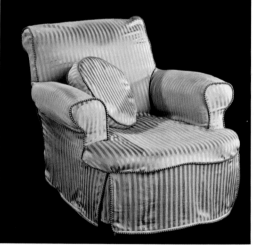

OCCUPANT: Horace Slughorn

FILMING LOCATION: Lacock village, Wiltshire, England

APPEARANCE: *Harry Potter and the Half-Blood Prince*

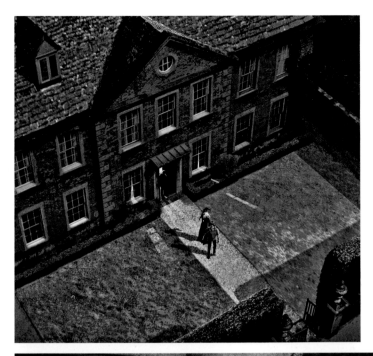

When Harry and Dumbledore arrive, the house is in a state of ruin, which is soon magically restored. To achieve this, visual effects first scanned the living room with everything in its proper place, and after a redress in which the furniture was damaged and the decorations cluttered, they scanned the room again. The scene was then shot in a mostly empty room, with only the actors Daniel Radcliffe (Harry), Michael Gambon (Dumbledore), and Jim Broadbent and a few pieces of furniture. The visual effects team then digitally animated each scanned prop to transform from wrecked to replaced as if on command, and they composited these animations with the live-action take.

THESE PAGES, CLOCKWISE FROM TOP LEFT: *Two pieces of concept art by Andrew Williamson of the village of Budleigh Babberton; Professor Dumbledore and Horace Slughorn in* Harry Potter and the Half-Blood Prince; *scattered and broken props suggest a break-in; the room restored; the fabric used for the armchair's upholstery was also used for Slughorn's pajamas.*

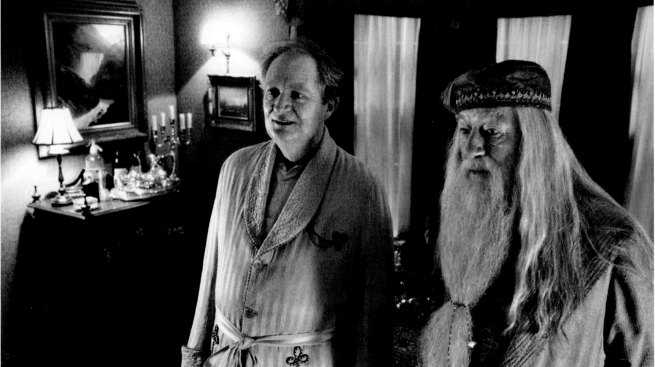

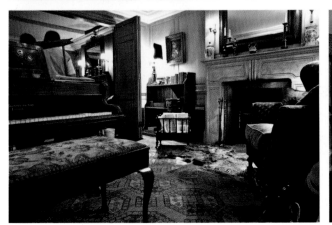

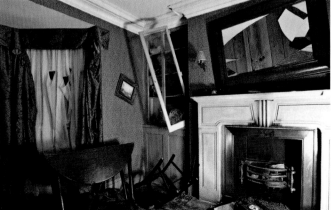

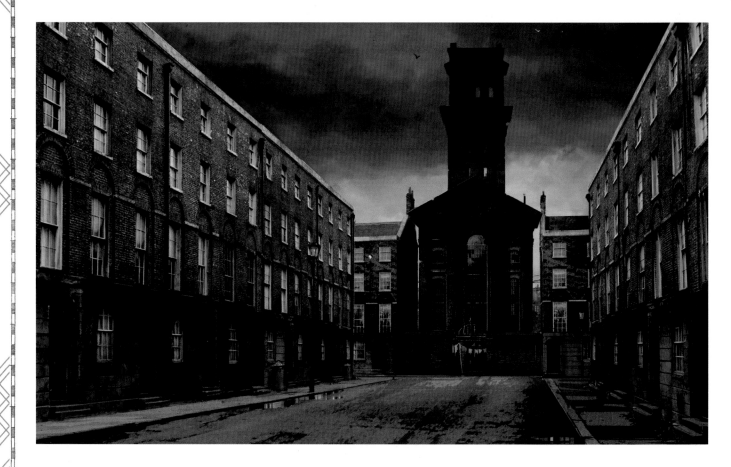

OCCUPANTS: Tom Riddle, Mrs. Cole

FILMING LOCATION: Leavesden Studios

APPEARANCE: *Harry Potter and the Half-Blood Prince*

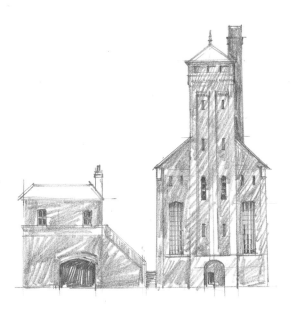

WOOL'S ORPHANAGE

Veteran production designer Stuart Craig knows that inspiration can come when it's least expected. For flashbacks of Tom Riddle viewed in the Pensieve during *Harry Potter and the Half-Blood Prince*, Craig needed to create Wool's Orphanage, the Muggle orphanage that serves as the young wizard Tom Riddle's childhood home. "Sometimes an idea can come straight out of your head, though more often it comes from something you've seen in a reference piece or physically during location scouting. Certainly, I've learned that you never reject anything. You never know what you'll bring away." Craig was scouting for locations for Severus Snape's home in Spinner's End, set in a riverside mill town. "While we were there," he recalls, "we were on one of those old, disused docks at Liverpool, and just by chance we saw this extraordinary Victorian building, so I photographed it. It's a huge red brick structure, very, very tall, dominating everything around it. Its central tower was monolithic. A real architectural curiosity. It wasn't appropriate as the orphanage itself, but nonetheless, it inspired the design."

Wool's Orphanage is set in London, not Liverpool. "We already had the façade of the partial London street built for number twelve, Grimmauld Place, so it was converted and adapted to fit another building. Now at the end of this rather derelict Georgian street is this very grim, sinister, prison-like structure." The interior of the orphanage was covered in a glazed Victorian-style tile. "This is very typical of Victorian institutions," Craig explains, "because, of course, it would last a long time and be easy to clean." Getting to Tom's room included traveling up long staircases and down long hallways in a sterile, severe environment. "It has a very distinct, oppressive look," he says. "It is not a happy place, believe me."

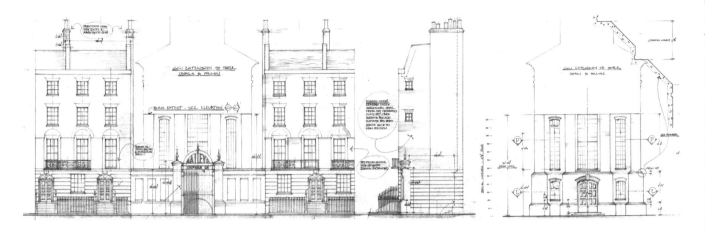

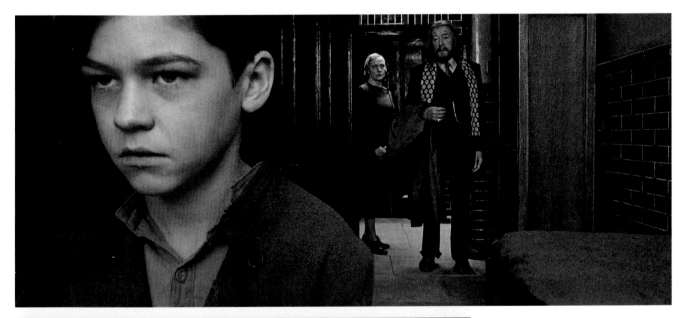

"TOM, YOU HAVE A VISITOR."

Mrs. Cole, *Harry Potter and the Half-Blood Prince*

THESE PAGES, CLOCKWISE FROM TOP LEFT: *Concept art by Andrew Williamson of the street leading to Wool's Orphanage; plans for the façade of the orphanage; a young Professor Dumbledore (Michael Gambon) enters the room of Tom Riddle (Hero Fiennes-Tiffin) at the orphanage in Harry Potter and the Half-Blood Prince; concept art depicting Professor Dumbledore's ascent to Tom Riddle's room; an early sketch by Stuart Craig of the orphanage.*

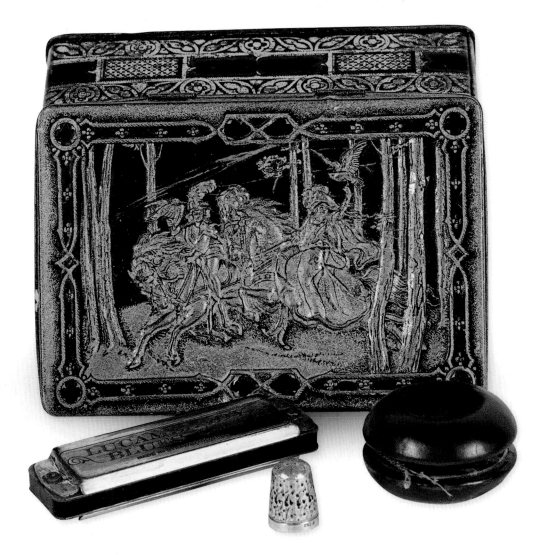

"THIEVERY IS NOT TOLERATED AT HOGWARTS, TOM."

Albus Dumbledore, *Harry Potter and the Half-Blood Prince*

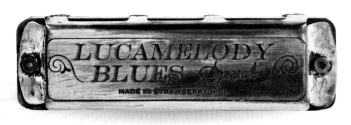

TOM RIDDLE'S TREASURES

In *Harry Potter and the Half-Blood Prince*, Harry Potter is shown the saved memory of Albus Dumbledore's first meeting with Tom Riddle in Wool's Orphanage. Dumbledore becomes aware of Tom's pattern of taking items, which will become a lifelong habit. Sharp-eyed viewers will notice seven rocks placed on the windowsill of his room, near a painting of an ocean cave—harbingers of the seven Horcruxes he will make and hide when he becomes Lord Voldemort.

A small tin box belonging to Tom contains, among other artifacts, a thimble, a harmonica, and a yo-yo. Throughout the Harry Potter films, when tasked with branding something that was not specified in the books, the graphic artists would cleverly construct these from their research or, depending on the artifact, their surroundings and their friends and families. The harmonica is manufactured by "Lucamelody," more than likely a reference to Miraphora Mina's son, Luca. Strawberry Hill, the place of the harmonica's manufacture, is the name of an estate previously owned by Horace Walpole, son of Britain's first prime minister and a compulsive collector, which is located only one hour from where the films were shot at Leavesden Studios.

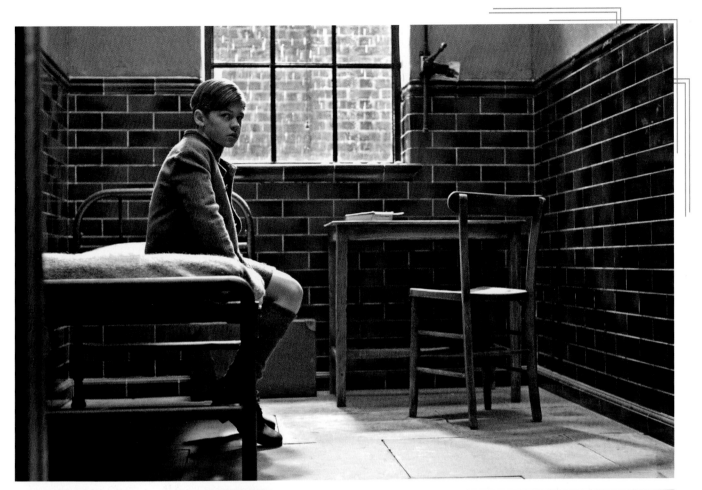

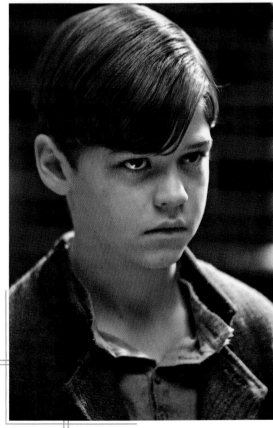

OPPOSITE: *Tom Riddle kept his "treasures"—taken from other students—in a blue-and-silver metal box in* Harry Potter and the Half-Blood Prince. *The box features a scene of wizards and witches holding birds of prey as they ride through a forest.* TOP AND LEFT: *The young Tom Riddle (Hero Fiennes-Tiffin) in* Harry Potter and the Half-Blood Prince. ABOVE: *The box of stolen treasures shakes in Riddle's wardrobe.*

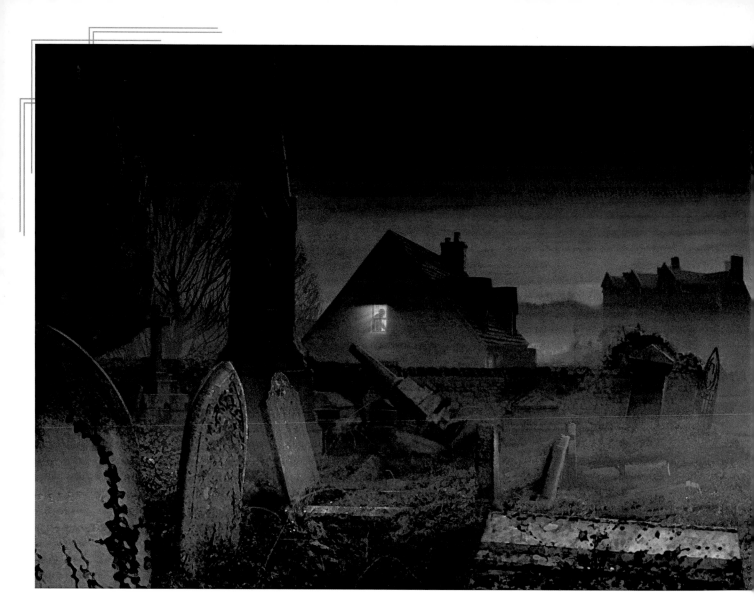

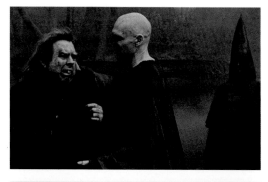

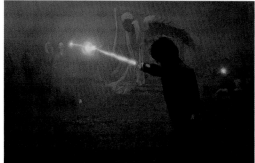

LITTLE HANGLETON GRAVEYARD

At the end of the Triwizard Tournament in *Harry Potter and the Goblet of Fire*, pretext and trickery transport Hogwarts champions Harry Potter and Cedric Diggory into a trap set up by Voldemort and Peter Pettigrew at the Riddle family gravesite. "The scene takes place in a large graveyard," Stuart Craig explains, "and I knew this was a very important set. It turned out to be one of our biggest sets." The scene was meant to be located on a small hilltop dotted with gravestones and statues, a landscape that was challenging to create. Little Hangleton graveyard was also meant to be very old, so Craig focused on evoking an ancient sensory feeling, crumbling and overgrown. "Essentially, it is about decay and dereliction. My inspiration for it was Highgate Cemetery in North London, which has been, in a way, reclaimed by nature." Built in 1839, Highgate Cemetery was planted with trees, bushes, and flowers that were allowed to grow without any restrictions.

The set was built indoors so that the eerie lighting and artificial fog that cover the misty graveyard could be controlled. "We can trap the fog inside," Craig says with a smile. "It's only practical—one good wind and the fog blows away." The ground was covered with living grass, and the set was crowded with huge, moss-covered tombstones, some of which bore the names of crew members' pets. The statue over the Riddle tomb that traps Harry was sculpted by Bryn Court, who had previously designed chess pieces, Dumbledore's owl podium, and the Hogwarts hogs for the Harry Potter movies, among other pieces. His original idea for the statue was of a beautiful angel draped over the tomb. This was changed to an "angel of death," given whose family tomb it was.

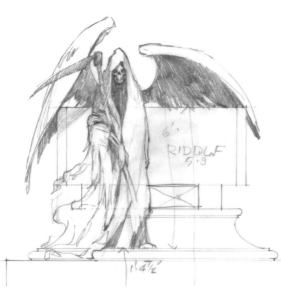

"CEDRIC, WE HAVE TO GET BACK TO THE CUP. NOW!"

Harry Potter, *Harry Potter and the Goblet of Fire*

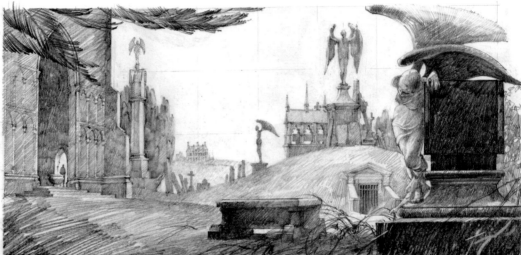

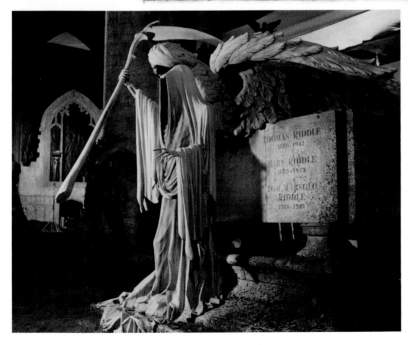

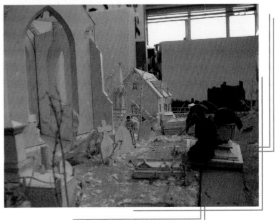

THESE PAGES, CLOCKWISE FROM TOP LEFT: *Concept art by Andrew Williamson; early sketches by Stuart Craig defined the final look of the Little Hangleton set; the Riddle family tombstone; a white card model made of the set; Harry Potter and Lord Voldemort during the graveyard scene of* Harry Potter and the Goblet of Fire; *Lord Voldemort greeting Peter Pettigrew (Timothy Spall).*

MALFOY MANOR

Malfoy Manor is the ancestral seat of the pureblood Malfoy family. In *Harry Potter and the Deathly Hallows – Part 1*, the home is appropriated by Lord Voldemort as a base of operations for his growing army. The action in the films took place on two huge sets, so Stuart Craig asked himself, what size place could house them? "In Malfoy Manor we would see a ground-floor entrance hall and a big drawing room immediately above that, linked with an elaborate staircase," he explains. "I decided to first look for an exterior to use as inspiration for the interior." One location that both he and Stephenie McMillan had long admired was the Elizabethan-era Hardwick Hall, built by Bess of Hardwick in 1590. Bess, who started from humble origins, was independent by nature and had acquired much wealth from four marriages. She designed Hardwick Hall, famously declared to be "more glass than wall." "Every façade is full of oversized windows," describes Craig.

"WHAT ABOUT YOU, LUCIUS?"

Lord Voldemort, *Harry Potter and the Deathly Hallows – Part 1*

"And I already knew that when it's dark inside the building, they have a mysterious, slightly threatening, and rather magical quality, these acres of glass with just darkness behind." He loved the glass windows, a sign of wealth at the time, but was disappointed by its roof. "So we invented a roof that seemed more part of the magical world, with spires that, in a way, linked it back to the Gothic spires of Hogwarts, but with a malevolent feeling. In the end, I think that silhouette was terrific. And sometimes it's a good and legitimate notion to just be different for the sake of being different." Craig had concept illustrations drawn with windows all blacked out or shuttered with blinds. "So this building, with these enormous glass windows, the eyes of the building, were in fact blind, and I think it makes a very impressive initial statement to see that exterior as Snape approaches the gate on the front drive." The interior followed through on the architectural

BELOW AND OPPOSITE: *Concept art by Nick Henderson visualizes the Malfoy Manor gate and the remote setting of the Malfoy home.*

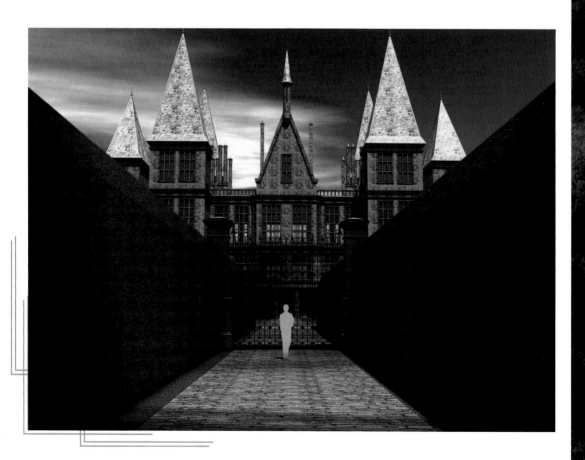

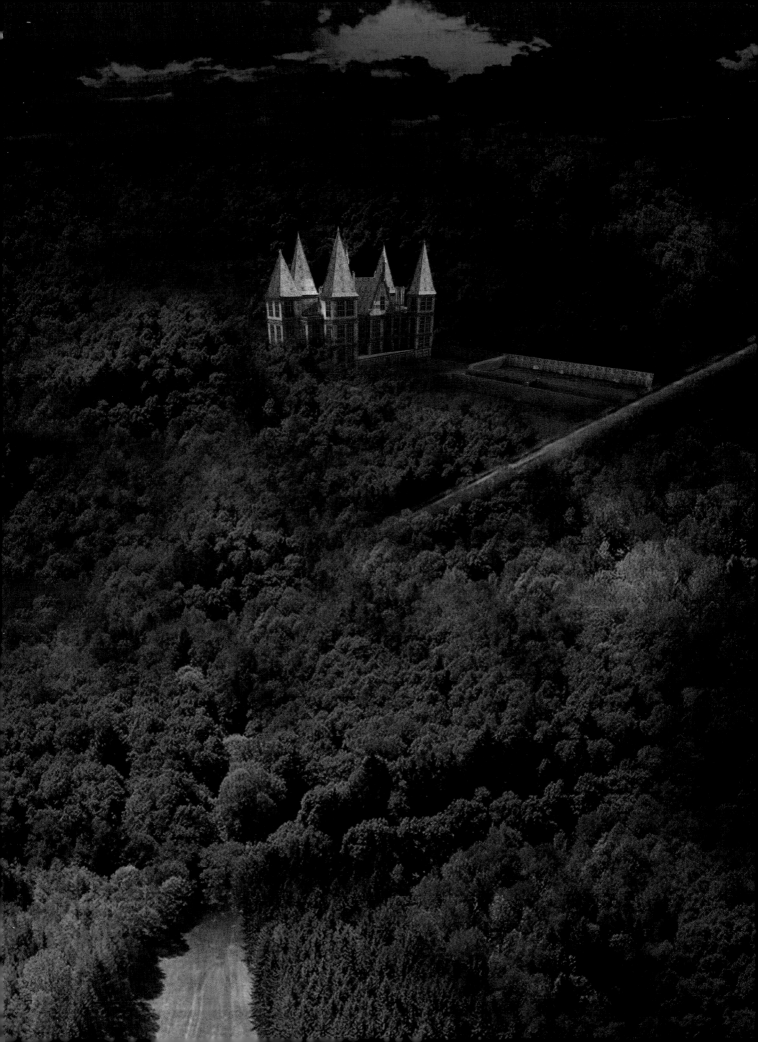

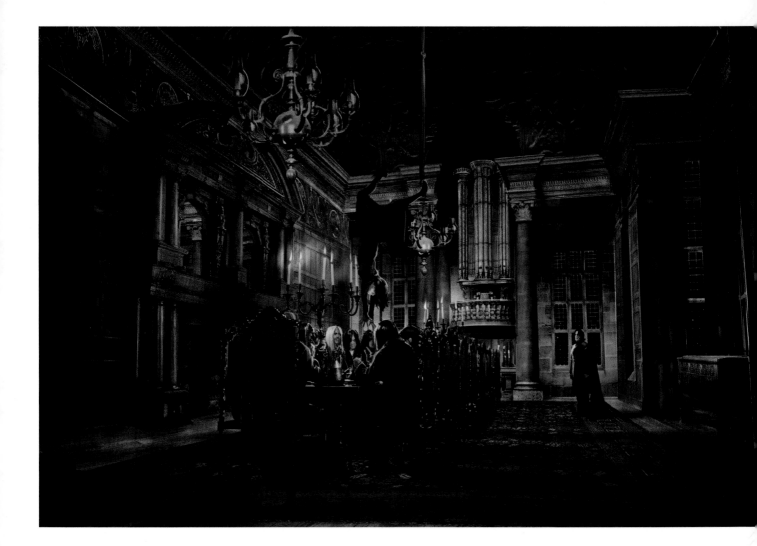

OCCUPANTS: Lucius, Narcissa, Draco Malfoy; Voldemort; Death Eaters

SET INSPIRATION: Hardwick Hall, Derbyshire, England

APPEARANCES: *Harry Potter and the Deathly Hallows – Part 1, Harry Potter and the Deathly Hallows – Part 2*

style. "It's a pretty muscular style. We made it deliberately very weighty. We don't know how wealthy Malfoy is, but the point is he's the heavyweight and villainous, and the architecture is big and sinister enough to reflect that." A staircase leads upstairs, although it only goes up into a single room. "There aren't any doors. There is just that double staircase that comes up into this room," says Craig. "And there are no further doors leading anywhere." The construction, he discloses, was story-driven. "From the bottom of the house you have to be able to hear Hermione's cry as she's tormented by Bellatrix in that upper room. So there can't be any barriers to the sound traveling. It was necessary for that to be the significant and only opening down the stairwell." Craig admits that it is a happy coincidence, or really, an unhappy one, that "once you're up there, you're trapped!"

Theatrical exaggeration was employed for the room where Voldemort meets with his followers, including a tall ceiling, one of the few ceilings created on a set, that sports a large chandelier. Art director Hattie Storey's design is a composite of five different chandeliers, hung with glass drops that would shatter in a controlled smash when the chandelier was released by Dobby. The fireplace is one of the biggest constructed for the films, and the center of the room contains a very impressive table. "We created a thirty-foot table for Malfoy Manor," says Stephenie McMillan, "surrounded by thirty Jacobean chairs made in the carpenter's shop." The table was made to come apart into two pieces for ease of shooting. "I imagined that there were props and pieces of furniture that would be very desirable to own at the end of the filming," Stuart Craig asserts, "but that one was pretty unwieldy. I'm not sure that table would survive a move to anywhere."

THESE PAGES, CLOCKWISE FROM TOP LEFT: *Concept art by Andrew Williamson depicts Charity Burbage hanging from the ceiling at a Death Eater meeting and the basement of Malfoy Manor; director David Yates on the set of Malfoy Manor in Harry Potter and the Deathly Hallows — Part 1; a blueprint by Hattie Storey for the construction of an armchair in the manor.*

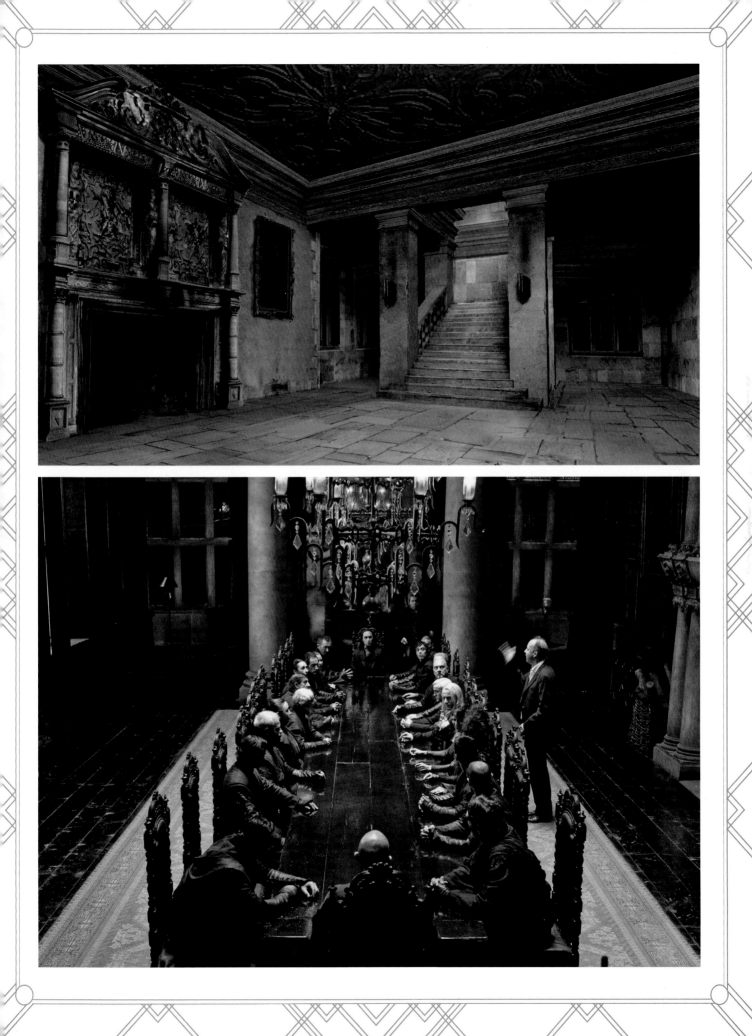

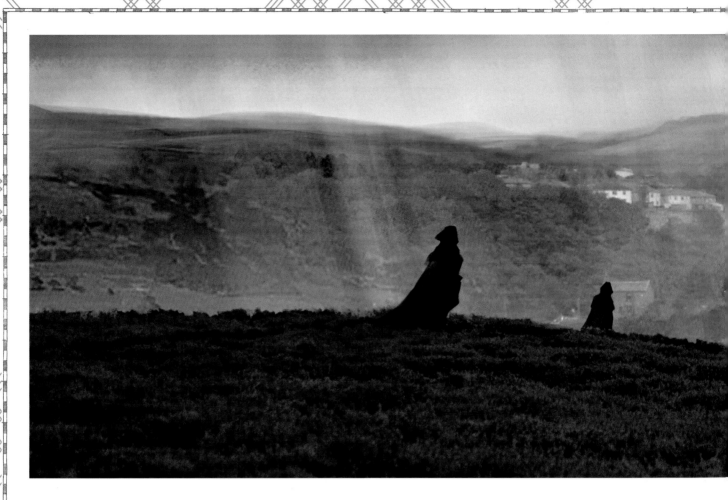

SPINNER'S END

OCCUPANTS: Severus Snape, Peter Pettigrew

FILMING LOCATION: Leavesden Studios

APPEARANCE: *Harry Potter and the Half-Blood Prince*

Sisters Narcissa Malfoy and Bellatrix Lestrange visit Spinner's End, the home of Severus Snape, in an early scene in *Harry Potter and the Half-Blood Prince*. Set in a mill town, where blocky, square brick buildings line the streets, known as "worker's rows," it is a sad, oppressive place to live. "Mill towns in England mean the cotton mills in Lancashire and the woolen mills in Yorkshire," Stuart Craig explains, "hubs of the nineteenth-century textile industry. We went to see them, to see all these houses, which are back to back to back in infinite rows. Quite a contrast to the Wizarding World." The houses were typically constructed with two rooms downstairs and two rooms upstairs with a tiny backyard entry leading to the outhouse. Craig actually considered shooting on location, but even though the buildings were intact, they had been brought into the modern era, with up-to-date kitchens and plastic extensions, so the set was built at the studio.

Stephenie McMillan furnished the Spinner's End interior with an eye toward its enigmatic, secretive owner. "In the book, Snape's house, really his parents' house, was filled with books, so we lined everywhere with books, but used primarily dark brown and blue and black bindings. That provided a sort of anonymity." McMillan also decorated the room with paintings that contained gray landscapes. As the room came together, Alan Rickman offered McMillan some creative insight. "He came onto the set to look at everything I had dressed it with. Then he suggested that he didn't think there would be any pictures in the room. I agreed, and removed them. It became even more impersonal and rather detached, echoing Snape's character."

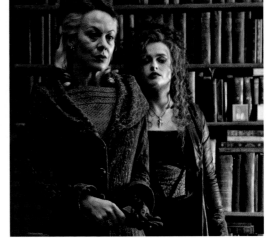

THESE PAGES, CLOCKWISE FROM TOP LEFT: *Concept art by Andrew Williamson, for a scene that was never realized, depicts Narcissa Malfoy (Helen McCrory) and Bellatrix Lestrange (Helena Bonham Carter) approaching the mill town that is home to Spinner's End; Helen McCrory and Helena Bonham Carter on the Spinner's End set; Severus Snape (Alan Rickman) in* Harry Potter and the Half-Blood Prince; *a preliminary sketch by Stuart Craig.*

"PUT IT DOWN, BELLA. WE MUSTN'T TOUCH WHAT ISN'T OURS."

Severus Snape, *Harry Potter and the Half-Blood Prince*

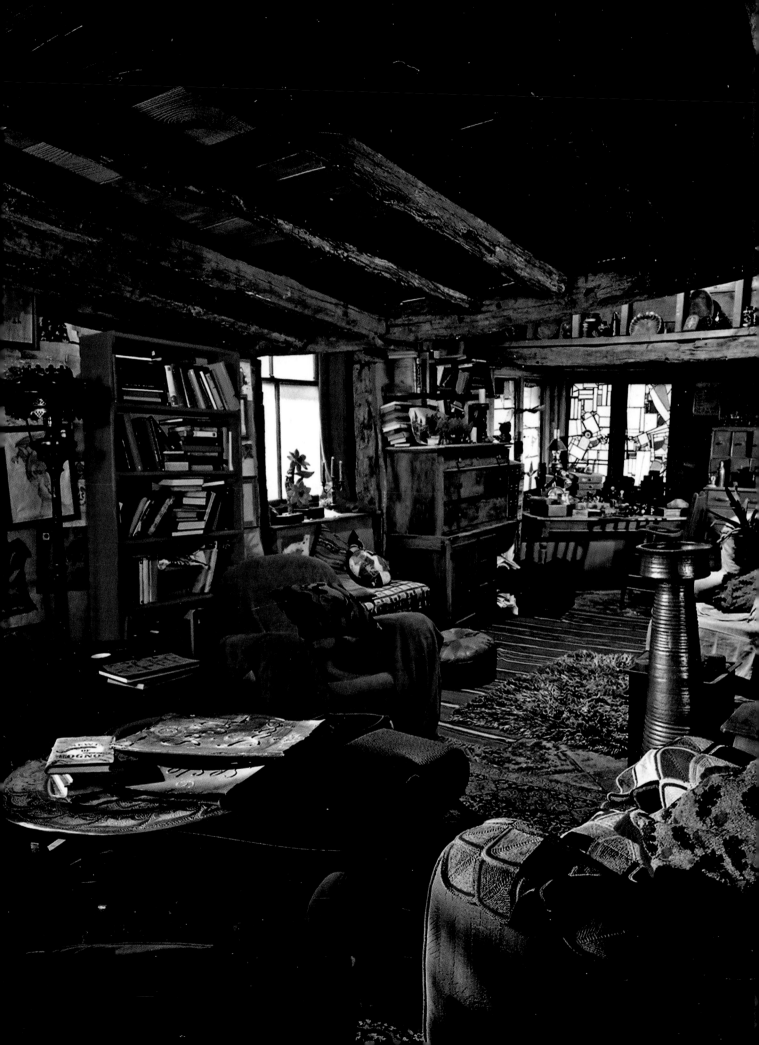

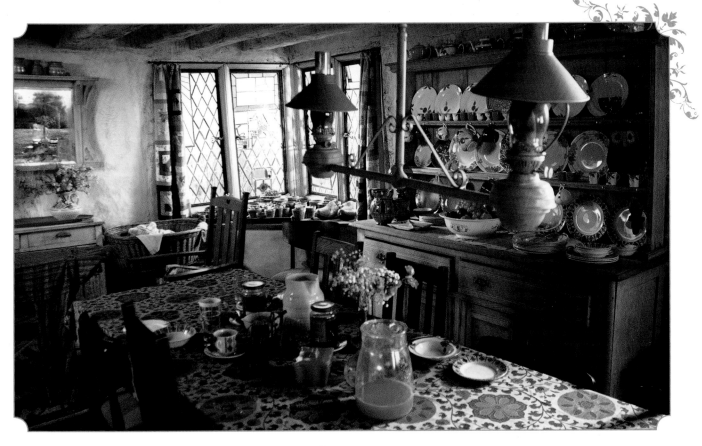

THE BURROW

Harry Potter's first visit to The Burrow, the home of
the Weasley family, occurs in *Harry Potter and the
Chamber of Secrets*, when Harry is rescued by Ron and
the twins after a torturous summer at number four,
Privet Drive. "It's not much, but it's home," Ron tells
him. Says director Chris Columbus, "Although The
Burrow is whimsical, quirky, and filled with magical
things, I also wanted it to feel like a warm family home,
a place where Harry could feel very comfortable."
Although its construction seems haphazard, Stuart
Craig insists there is a logic and level of reality to it. "The
books mention a pigsty there, so I attached a pigsty to
a very simple square, single-story dwelling that could
have been a Tudor structure; this was the foundation
for the whole thing." Craig maintains that Arthur
Weasley continued to build the house vertically instead
of laterally, into an "eccentric tower," and because his
interest is in Muggle things, he would have built it out
of architectural salvage. "Muggle salvage, really. So it
is a mad wizarding home, but built out of very real,
recognizable materials. His roof structure is clad with
slates and tiles and wooden shingles, anything he could
acquire. An amazing chimney grows through the core
of it, and all the extended rooms cling onto that, making
it a sort of vertical pile." Craig felt that the best place to
site a vertical structure was in flat terrain. "We visited
this beautiful marshland just inshore from Chesil Beach
in Dorset, and imagined our structure in that place.
As the only vertical thing in the frame, it created an
interesting visual." Placing The Burrow in a marsh also
gave it a remoteness that Craig thought was important
to keep it detached from the Muggle world.

OCCUPANTS: Arthur, Molly,
Bill, Charlie, Percy, Fred, George,
Ron, and Ginny Weasley

FILMING LOCATIONS: Chesil
Beach, Dorset, England; Leavesden
Studios

APPEARANCES: *Harry Potter
and the Chamber of Secrets, Harry
Potter and the Goblet of Fire, Harry
Potter and the Half-Blood Prince,
Harry Potter and the Deathly
Hallows – Part 1*

OPPOSITE: *A set photograph of The Burrow
living room.* ABOVE: *An earthy color palette
was used for the set of The Burrow dining
room.* BELOW: *A sketch by Stuart Craig of The
Burrow placed it in the field adjoining the back
lot of Leavesden Studios.*

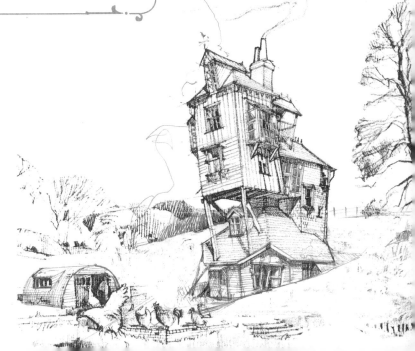

The Burrow's interior was designed with a similar logic. Stephenie McMillan furnished it with disparate items and mismatched decorations. "The stairs have different carpet every third step," she explains. "None of the doors or windows match. The idea was that they shopped at secondhand shops and thrift stores, or picked things up from the curb, and that many things were acquired from Mr. Weasley's job for the Ministry of Magic. Nothing was new." The Weasleys' clock keeps track of the family's whereabouts, whether they're at home, school, or worse. "That's my favorite prop from all the films," says Daniel Radcliffe. "It shows where they are and what's happening to them, even if they're in mortal peril." The clock's hands were made from scissor handles filled with green-screen material. The walls were decorated with artwork drawn by children of the art department crew, and the prevailing palette reflected the ginger-topped Weasleys' obvious favorite colors: red and orange. McMillan also decorated with Mrs. Weasley's choice craft in mind, employing a knitter to create pillow tops, tea cozies, and, in *Goblet of Fire*, something special for Ron's bedroom. "Shirley Lancaster knitted a huge orange patchwork bed cover with the word Chudley on it, for his favorite team, the Chudley Cannons, and a flying Quidditch player, which is quite spectacular," says McMillan, who lists it among her favorite props for the films.

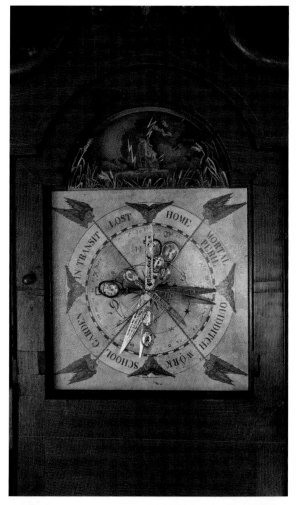

Harry stays over at The Burrow again in *Goblet of Fire* and spends Christmas there in *Harry Potter and the Half-Blood Prince*. During the holiday, Death Eaters attack and set fire to The Burrow, a special effect that could only be done once. Art director Gary Tomkins created a one-third-size, twenty-foot-high miniature, which took six months to build and six minutes to burn down. The Burrow model had to exactly match the full-size set, so everything was replicated, including tiny leaded windows, orange curtains, and brick chimneys. The miniature matched in absolutely every way, including the log basket and pig trough in the garden.

As a result, for *Harry Potter and the Deathly Hallows – Part 1*, Craig and McMillan faced the challenge of creating a new version of the Weasley home. "It has new timbers and it's freshly painted, so it's less eccentric than it was before . . . but only slightly," says Craig. "We completely changed the furniture and gave them

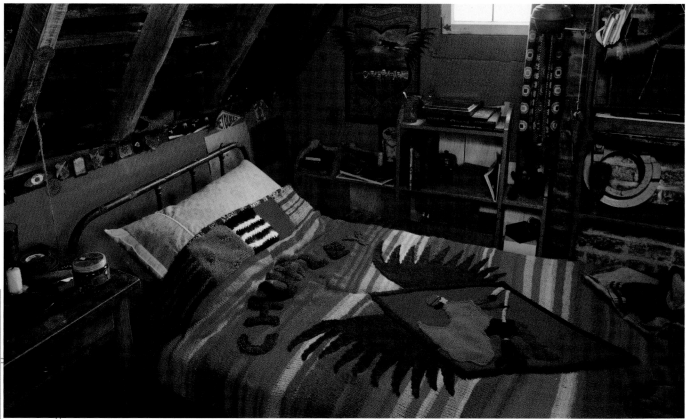

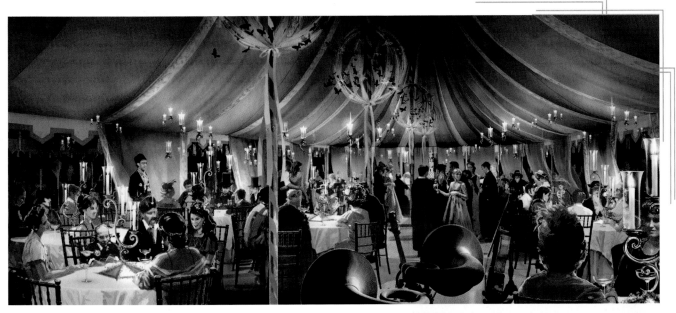

a new kitchen and a piano," adds McMillan. "We kept the cast-iron fireplace, which would have survived, but otherwise, we replaced it all." McMillan and her team purchased mismatched china and chairs and worn furnishings at flea markets and garage sales, but looked for more contemporary items, deciding that Molly Weasley would take the opportunity to update the home.

"It is gorgeous and homely," says Julie Walters, who plays Molly Weasley. "It's not about appearances or ambition or anything like that, it's about love and protection and care, and that's why the Weasleys are so special. I want to live there myself. It's just divine!"

At the opening of *Deathly Hallows – Part 1*, family and friends gather for the wedding of the Weasleys' eldest son, Bill, to Fleur Delacour, the Beauxbatons champion in the Triwizard Tournament. "We decided to say that Fleur Delacour's parents had a big influence on the wedding," explains Stuart Craig. "In fact, Mr. Delacour would probably pay for it as father of the bride, so that permitted a French influence. We really went with that—there's a very refined soft interior, painted silks, and floating candles in eighteenth-century French-style candelabra. The whole thing has an elegant and quite un-Weasley-like look about it. It's a nice contrast with the house." Just as silver encased the Great Hall at the Yule Ball, purple trappings fill the tent: flowers, tablecloths, and carpets. The wedding tent was woven in Pakistan and lined with Indian silk printed with a scrolling French motif border in purple to complement its amethyst color. McMillan also located black faux-bamboo chairs that she considered quite "wizardy." Black butterflies created by visual effects flit around the tent poles. Craig and McMillan were briefed at the start on the number of wedding guests. "We did a seating plan quite early on with the Weasleys at one big round table, and the Delacours at another. Additional tables seated groupings of six guests, so I think it was about one hundred and thirty people all together." McMillan declared that she never wanted to do another wedding design after this one. "It's too stressful!"

The props department "catered" four thousand artificial petits fours, small cakes, and chocolate éclairs, which were displayed on rubber molded stands. Since everything goes flying when the reception is invaded by Death Eaters, for safety, nothing could be used that was metal or glass. The four-tier wedding cake was iced in a design called treillage, based on trellis arches used in eighteenth-century French gardens.

Almost six hundred sets were created for the Harry Potter films, as diverse as a wizarding tent, a sweetshop, a Potions classroom, a hidden house, and a gamekeeper's hut. "Each film would come with a completely new collection of sets and props that needed to be built," Craig recalls. "There was always a constant stream of new work to be done, but that was what was wonderful about it."

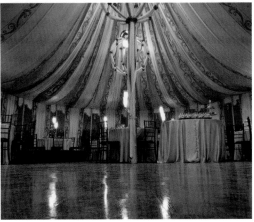

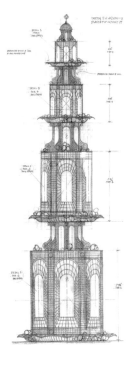

"I THINK IT'S BRILLIANT."

Harry Potter, *Harry Potter and the Chamber of Secrets*

THESE PAGES, CLOCKWISE FROM TOP LEFT: *The Weasley clock has a hand for each member of the family; art by Andrew Williamson depicts the lavish, French-inspired wedding tent; a view of the set created for* Harry Potter and the Deathly Hallows — Part 1; *blueprint for the construction of the elaborate wedding cake by Emma Vane; a hand-knit blanket by Shirley Lancaster celebrates the Chudley Cannons.* PAGES 62–63: *The wedding of Bill Weasley and Fleur Delacour, as depicted by Andrew Williamson for* Harry Potter and the Deathly Hallows — Part 1.

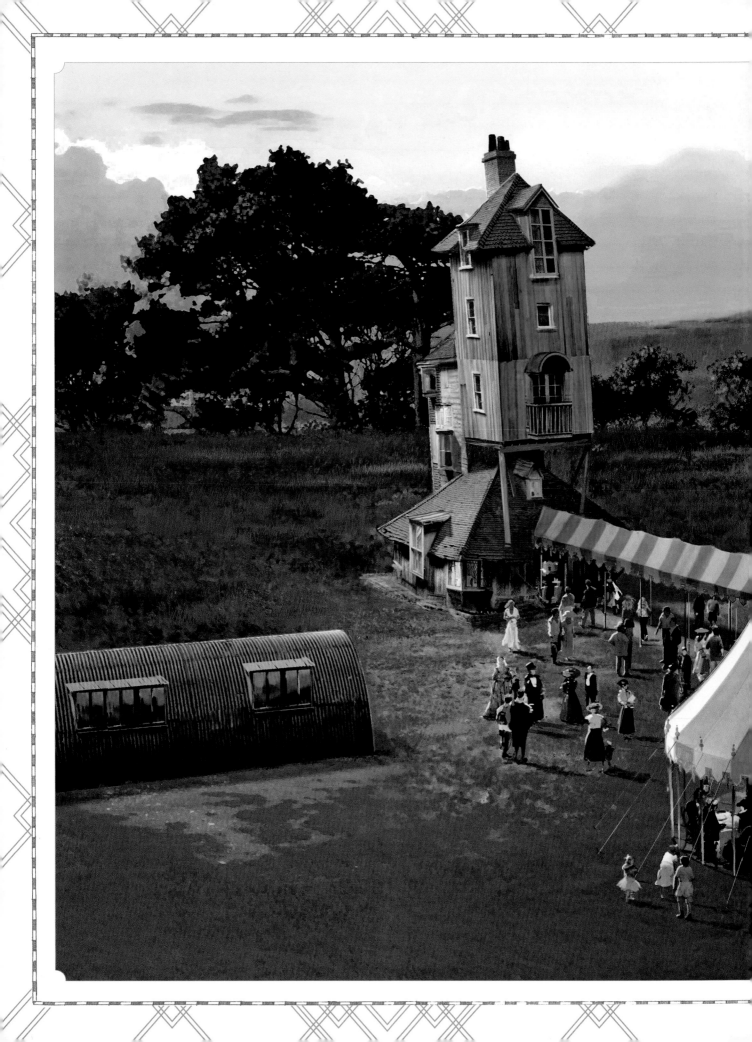

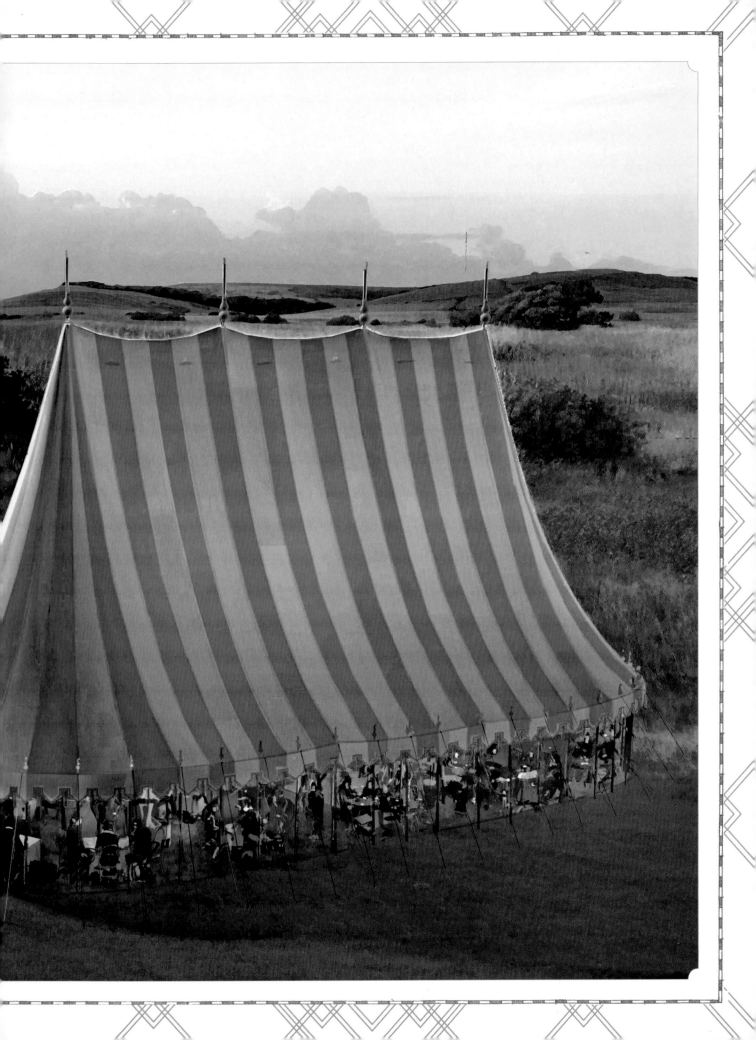

INSIGHT
EDITIONS

PO Box 3088
San Rafael, CA 94912
www.insighteditions.com

Find us on Facebook: www.facebook.com/InsightEditions
Follow us on Twitter: @insighteditions

Library of Congress Cataloging-in-Publication Data available.

ISBN: 978-1-68383-834-0

Publisher: Raoul Goff
President: Kate Jerome
Associate Publisher: Vanessa Lopez
Creative Director: Chrissy Kwasnik
Design Support: Megan Sinead Harris
Editor: Greg Solano
Managing Editor: Lauren LePera
Senior Production Editor: Rachel Anderson
Production Director/Subsidiary Rights: Lina s Palma
Senior Production Manager: Greg Steffen

Written by Jody Revenson

Insight Editions, in association with Roots of Peace, will plant two trees for each tree used in the manufacturing of this book. Roots of Peace is an internationally renowned humanitarian organization dedicated to eradicating land mines worldwide and converting war-torn lands into productive farms and wildlife habitats. Roots of Peace will plant two million fruit and nut trees in Afghanistan and provide farmers there with the skills and support necessary for sustainable land use.

Manufactured in China by Insight Editions

10 9 8 7 6 5 4 3 2 1